Painting
Boats &
Harbours
in Watercolour

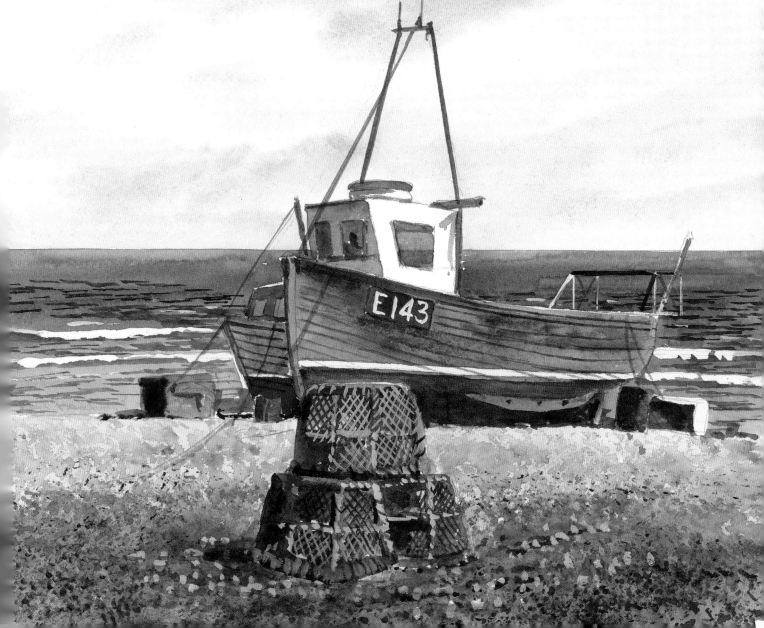

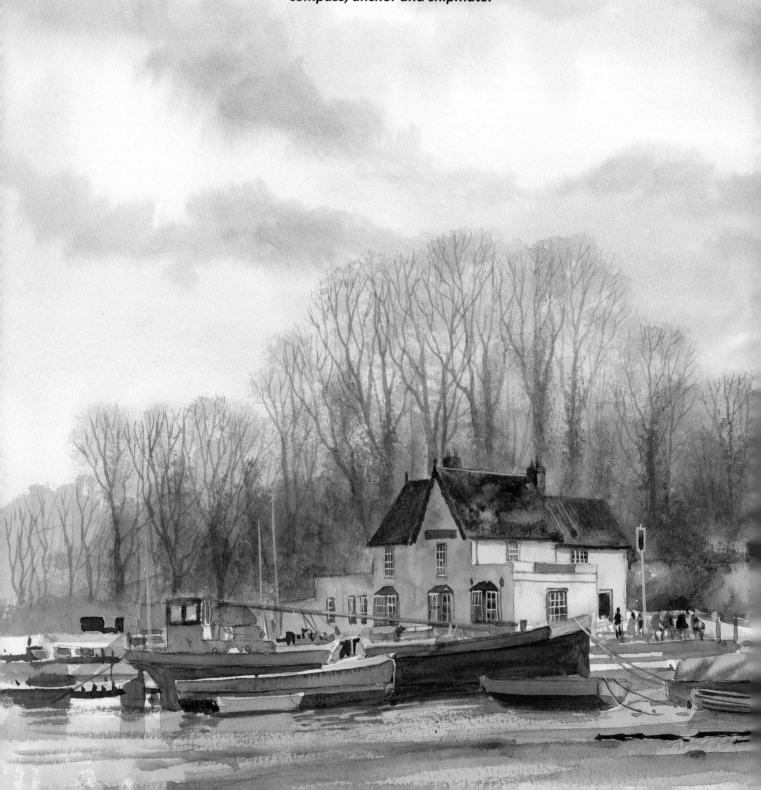

Dedication

This book is dedicated to my wife,
Fiona Peart (Harrison); thanks for being my
compass, anchor and shipmate.

Painting
Boats &
Harbours
in Watercolour

Terry Harrison

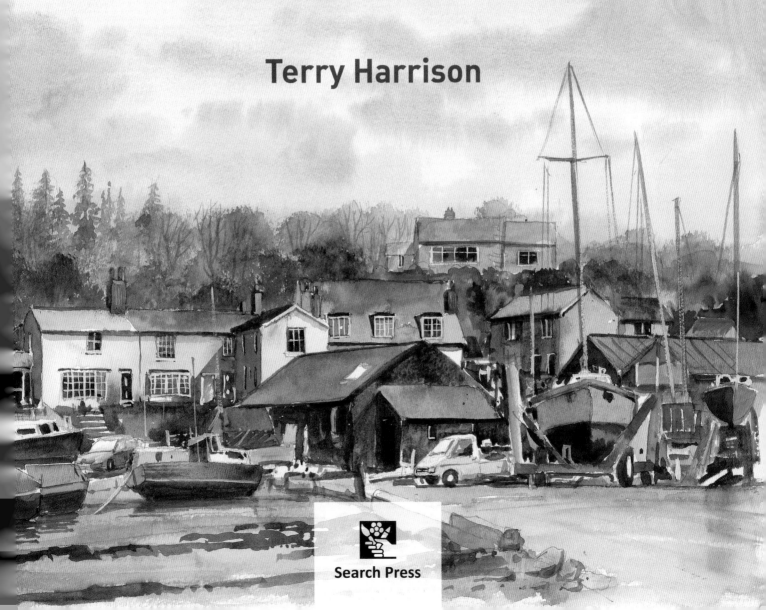

Search Press

First published in Great Britain 2014

Search Press Limited
Wellwood, North Farm Road,
Tunbridge Wells, Kent TN2 3DR

Reprinted 2015, 2016, 2017

Text copyright © Terry Harrison 2014

Photographs by Paul Bricknell at Search Press Studios
Photographs and design copyright
© Search Press Ltd 2014

ISBN: 978-1-84448-954-1

Suppliers
If you have any difficulty obtaining any of the materials and equipment mentioned in this book, please contact Terry Harrison at:

Telephone: +44 (0)1451 820014

Website: www.terryharrison.com

Alternatively, visit the Search Press website:

www.searchpress.com

Publisher's note
All the step-by-step photographs in this book feature the author, Terry Harrison, demonstrating watercolour painting. No models have been used.

Printed in China through Asia Pacific Offset

Acknowledgments
My thanks to my editor, Sophie Kersey, for navigating me through the tricky waters of writing this book! Also my thanks go to my wife, Fiona, for all her help in keeping the captain's log up to date. To Spud, thanks for the photos.

Front cover
Island on the Lake
When you are choosing a location or a subject to paint, don't just plonk yourself down in front of it and start painting – take your time and think about what attracted you in the first place and concentrate on that. If you are in doubt, ask yourself, is this a place I want to be? With this painting of the two boats and the island on the lake, it only took a moment looking at the scene before I was reaching for my paints.

Page 1
Lobster Beach
The boats are high and dry on the shingle beach, and in the foreground, placed in the centre, are some lobster pots. These tell the viewer that these are working boats and mean business.

Pages 2–3
All Along the Waterfront
This panoramic view captures all that is Pin Mill, in Suffolk, UK. At one end is the riverside pub for refreshing the weary sailor and at the other end is the boatyard that helps keep everything afloat.

Opposite
Beside the Quay
On one side of this river estuary is a busy marina, lots of boats, masts and simple shapes reflected in the still water. In contrast are the boats in the foreground: strong bold shapes with lots of detail. The eye is drawn to the quayside boats first, then led over the water into the painting, then out to sea.

Contents

Introduction

I am not a sailor; in fact I am what some might call a landlubber
(a disparaging nautical term for someone who knows little about boats
and the sea). This book is therefore a landlubber's guide to painting boats
and harbours. You don't need to know how a boat is made or indeed how
to sail it, to be able to paint it; all you require is a passion for painting
and this book! I have always loved painting boats, which may stem from
a strong naval tradition in my family. My parents met in the 1940s in the
historic Chatham Dockyard ropery, where they both worked making rope.
In fact it wasn't long before they tied the knot!

My first introduction to all things nautical was visiting my family in
the Medway towns as a child, when every year as a treat there was a trip
to the open Navy Days in Chatham Dockyard. My favourite experience
was travelling up the River Medway on the little paddle steamer, the
Medway Queen, from Rochester to Southend, chugging across the
Thames Estuary past countless working Thames barges plying their trade
in full sail; a sight I will never forget. A painting that reminds me of these
days is *The Fighting Temeraire* by my favourite artist, J M W Turner. How
strange that, as a landscape artist, I have chosen a marine painting as
my favourite.

What is it about boats and the seaside that attracts artists? Is it
because they make such a fabulous subject to paint? Many say it is
because in Britain we are an island nation surrounded by water, but what
about the rest of the world? Let's face it, wherever you find water and
boats around the world, you'll probably find an artist painting the scene.
Some boats and harbours make for better subjects than others. As artists,
we try and find something out of the ordinary in a scene; a hook that
draws us in and makes us want to paint it. This might be the sun setting
over the abandoned hulk of a boat stranded on the mud flats, or a tall
ship in full sail in a storm.

In this book I have compiled some of my favourite coastal sights and
scenes and I share with you the techniques and tips I have used to create
them, including how to work from photographs. This is not cheating;
many, if not all, artists I know use photographic reference, but they might
choose not to mention it. There are not too many artists these days tying
themselves to the mast of a ship in the middle of a storm to capture the
experience in watercolour.

I have tried to avoid using technical and nautical terminology, because I'm not sure it helps with painting. You do not have to swallow a boat builder's manual to paint a boat. Knowing the name of a particular sail will not make you paint it any better, but knowing the shape of it will, so take your camera wherever you go and gather plenty of reference.

Messing about in boats is great fun, I am told, but this landlubber much prefers to stay on solid ground and simply paint them.

Summer Moorings

The evening sun lights up the side of the riverside pub, and the barges anchored at their moorings. The dark trees frame the building, then, as the trees retreat back into the distance, changing colour, they become lighter and bluer, adding depth to the painting.

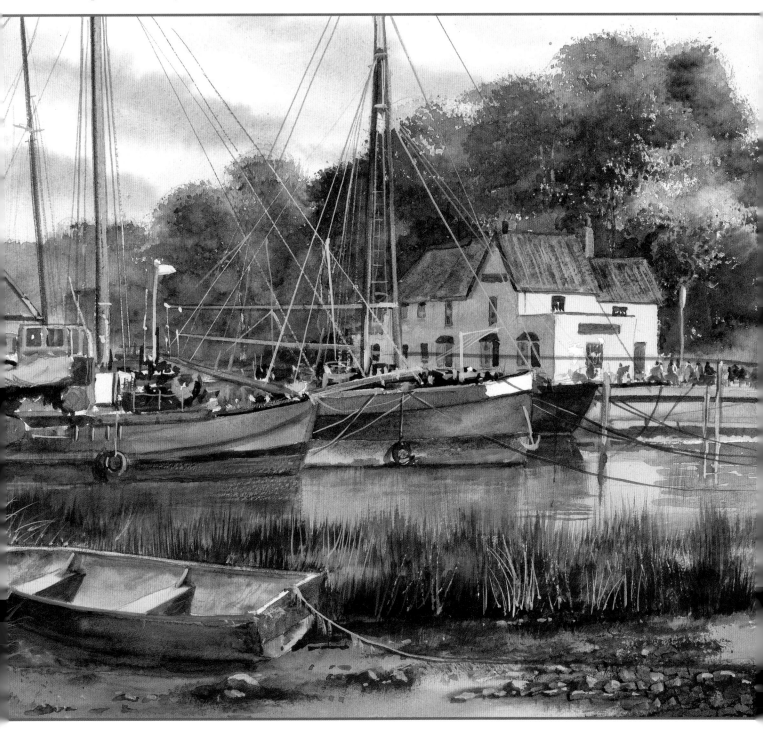

Materials

Paints

You can buy watercolour paints in pans or tubes. I prefer tubes, as they are good for large washes such as those used for seas and skies. I squeeze them out into a palette in a particular order so that I know where they are, and always mix enough of the washes I need before beginning to paint.

It is advisable to buy the best paints you can afford. Students' quality colours contain less pigment, so you may need more of them, and the results are not as vibrant as they might be. I always use artists' quality paints, as I find the results are better.

Brushes

I have my own range of brushes, which I had specially designed to help you achieve the best effects with the minimum effort, and I have used these in this book. You can of course use a different range of brushes, but look for the attributes described below. The Tip (right) will help you to find alternatives.

The golden leaf brush holds lots of paint and is ideal for sky washes and for painting water.

The large, medium and small detail brushes are round brushes. The large detail brush holds lots of paint and is good for washes, but also has a good fine point. The medium detail brush also holds quite a lot of paint but has a good enough point to paint all but the finest detail, and the small detail brush, as its name suggests, is designed for painting the finest details.

The 19mm (¾in) flat brush is useful for painting washes and for painting or lifting out larger ripples. The 13mm (½in) flat brush is good for straight lines and smaller ripples.

The foliage brush is good for painting texture, and the summer foliage brush is a larger version of this which can also be used for washes. The foliage px has an acrylic resin handle which can be used for scraping out paint.

I also use a half-rigger, which has long hair, holds a fair amount of paint, and as its name suggests, is good for painting the rigging of boats and other fine details.

I have a masking fluid brush to avoid spoiling good brushes with gummed-up latex, but you can use an old brush if you protect it with soap before dipping it in the masking fluid.

Paper

Watercolour paper can be bought in three surfaces: Hot Pressed (or smooth), Not (cold-pressed or semi-smooth) and Rough. Rough paper is good for effects like the dry brush technique, because of its textured surface.

Paper also comes in different weights, and the lighter weights tend to cockle when wet, so many artists stretch them before painting. I use 300gsm (140lb) paper, which does not need stretching.

I have used 300gsm (140lb) Not paper for all the paintings in the book.

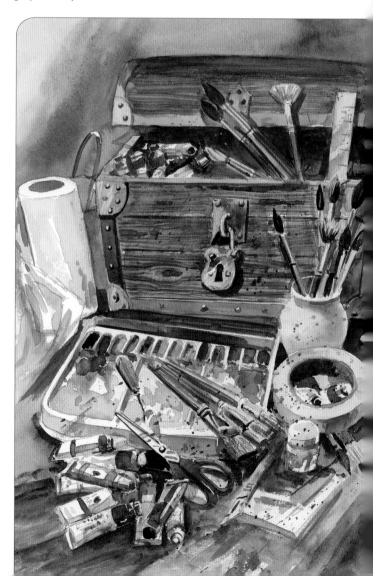

Artist's Treasure Chest

Tip

The golden leaf brush is mainly used as a wash brush in this book, so could be replaced by another large wash brush.

The large, medium and small detail brushes could be replaced by no. 12, no. 8 and no. 4 round brushes.

The 19mm (¾in) flat brush is the same as those used in other ranges.

The foliage brush could be replaced by a 10mm (³⁄₈in) one-stroke.

You could use a rigger brush instead of the half-rigger.

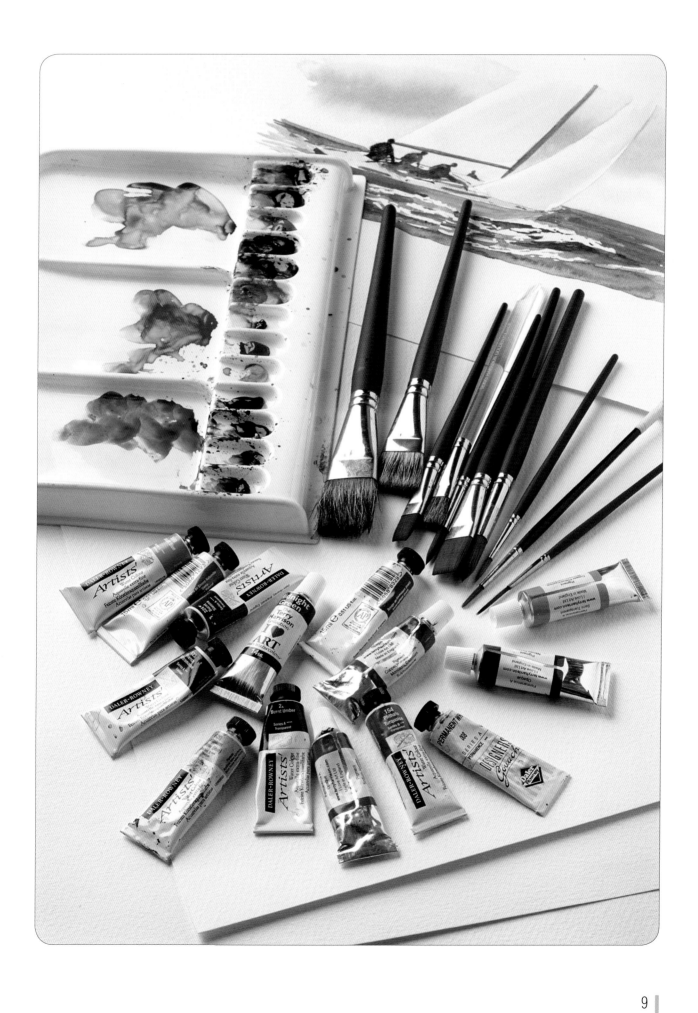

Other materials

I use masking tape to tape my watercolour paper to a drawing boad. Masking tape can also be used to create a straight horizon.

A hairdryer is used to speed up drying times between painting stages.

Many artists use jars as water containers, but I use my trusty bucket, as this way my brushes stay clean and I don't have to keep changing the water while I am painting.

Tracing paper, pencils, a fineliner pen and a spoon are all used during the process of transferring an image from a photograph to your watercolour paper. The spoon handle takes the place of a burnisher to rub over the back of the tracing paper, transferring graphite lines on the front on to the watercolour paper. See the Using photographs section on pages 14–15.

The eraser is used to erase any mistakes or to soften a pencil drawing.

Tracedown paper can be used as an alternative to tracing paper and pencils to transfer the image (see page 15).

Masking fluid is a liquid latex solution used to mask areas where you want to preserve the white of the paper, such as the crest of a wave, a white sail or gulls (as in the painting shown below). It allows you to paint washes over and around these areas without needing to leave a gap.

A flexible curve can be useful to help you draw the edges of sails.

A digital camera is a useful tool for an artist. Photograph any scene that inspires you from different angles to get plenty of reference details. Print it out to the size you want, and you can use the methods on pages 14 and 15 to transfer the outline on to your watercolour paper.

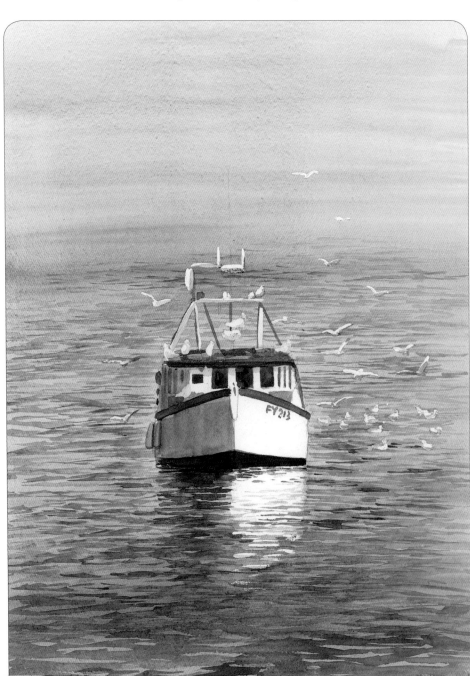

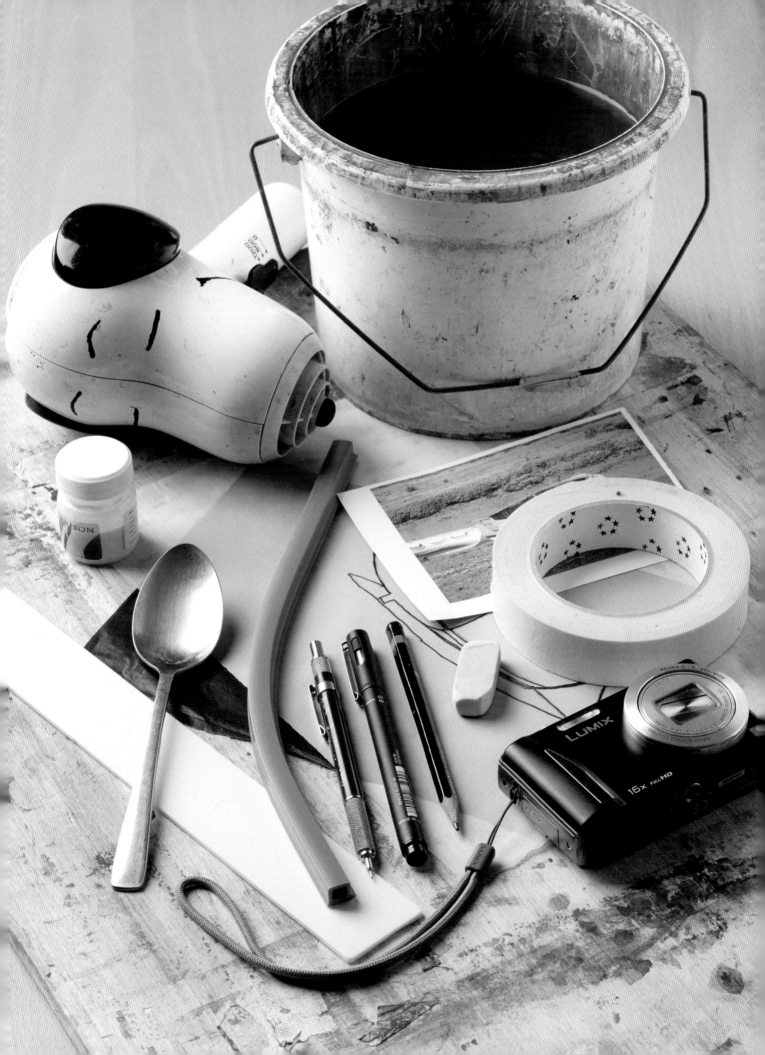

Showing your colours

Here are a few of the colours and colour mixes that I have used in many of the paintings in this book. I have some of the colours made specially, and these are available for you to buy, but if you don't have them and want to make your own alternatives, try the following mixes. To make shadow, mix French ultramarine, burnt sienna and permanent rose. Midnight green can be replaced with Hooker's green, country olive with olive green and sunlit green with green gold.

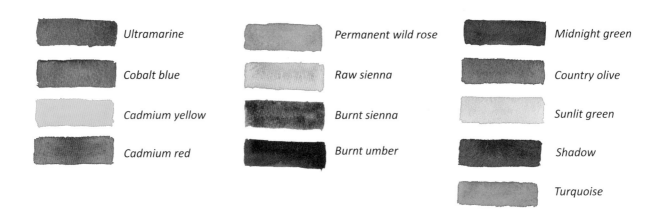

Ultramarine

Cobalt blue

Cadmium yellow

Cadmium red

Permanent wild rose

Raw sienna

Burnt sienna

Burnt umber

Midnight green

Country olive

Sunlit green

Shadow

Turquoise

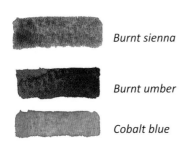

Burnt sienna

Burnt umber

Cobalt blue

Rusty paintwork

For painting a rusting surface on a boat, use a wet cobalt blue, then drop burnt sienna and burnt umber into it wet into wet.

Raw sienna

Burnt umber

Ultramarine

Distressed paintwork

Another combination useful for painting distressed paintwork on boats is ultramarine with raw sienna and burnt umber. Again, use the wet into wet technique.

Raw sienna

Cobalt blue

Sails

Raw sienna with cobalt blue is a good mix when painting sails.

Raw sienna

Burnt sienna

Cobalt blue

Beaches

A useful mix when painting beaches is a combination of raw sienna and burnt sienna with cobalt blue.

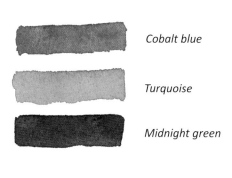

Cobalt blue

Turquoise

Midnight green

Warm seas

Cobalt blue, turquoise and midnight green are a good combination when painting the sea in sunny conditions.

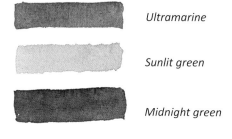

Ultramarine

Sunlit green

Midnight green

Deep seas

Ultramarine, sunlit green and midnight green combined in varying proportions can create realistic deep water.

Using photographs

I am now going to touch on two taboo subjects, using photographs and using tracing paper. I use both, and you have permission to do the same. To capture a moment in time, use a camera. I would love to say, work only from life; painting outside is a joy – but there are drawbacks. The weather changes, the sun goes in and the tide goes out, so the perfect scene for your next masterpiece has suddenly changed beyond all recognition. For this reason, always photograph the subject as it is when it first inspires you, since it will change later. Most artists have a digital camera or a mobile phone camera. Photograph your subject from different angles, as any spares might come in handy for another painting.

Choose the view you want, load the shot on to your computer, then print it out to the size of your intended painting. An alternative method is to photocopy your reference photograph, enlarging it to the size you want, then trace the image with a fineliner pen. When you have traced the information you need, transfer the image on to watercolour paper (see opposite) and you are ready to paint.

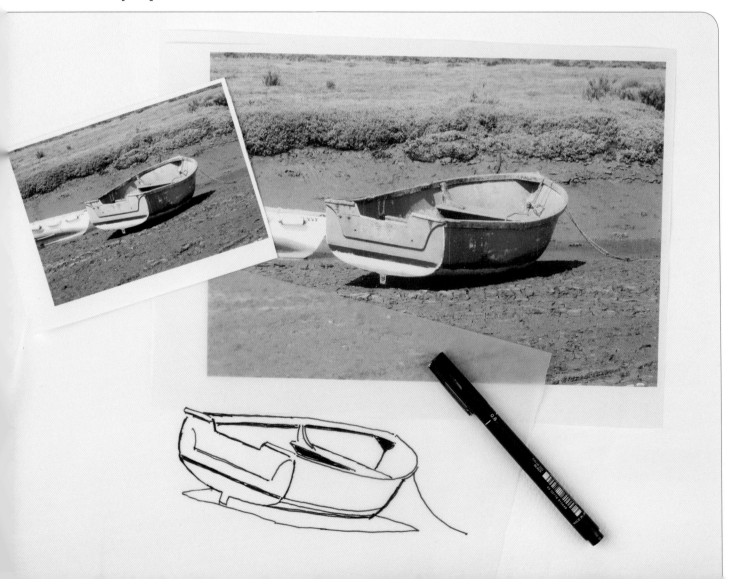

Transferring the image

Using tracedown paper

1 Place tracedown paper over the watercolour paper and the tracing on top of this. Go over the lines of the image with a pencil.

2 Lift up the tracedown paper to reveal the image transferred on to watercolour paper, ready for you to begin painting.

Using tracing paper

1 Place the tracing face down and go over the lines on the back with a soft pencil.

2 Tape the tracing face up on your watercolour paper and go over the lines on the right side with the handle of a spoon.

3 Lift up the tracing to reveal the image transferred on to watercolour paper.

Using a window

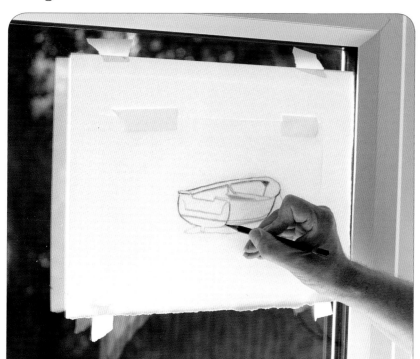

You can use a window or patio door as a light box. Tape your tracing on to the glass, then position your 300gsm (140lb) watercolour paper on top. The light should be strong enough to enable you to see the drawing through the watercolour paper, so you can then trace it with a pencil on to the watercolour paper.

Getting started

Learning the ropes

When it comes to learning how to draw boats, start small; I would suggest starting with something like a rowing boat. Don't launch yourself into a full-blown painting of something along the lines of the *Titanic* – it could end in disaster! Rowing boats make for a great foreground focal point and they come in all shapes and sizes.

Draw your boats using photographic reference, as it is very difficult to draw from memory. Over time, you can build up quite a stock of different boats. A good tip is to photograph your chosen subject from different angles: start from the front, head on, then move around and take a shot three-quarter front, then take a side view, then move round to the rear. Photograph the boat in the foreground, without getting too close, then move back and repeat the shots from the middle distance. In no time at all, you will build up quite a selection of reference material that you can draw on to add to your painting.

Page 15 shows you how to transfer drawings from your photographs on to watercolour paper, ready for painting.

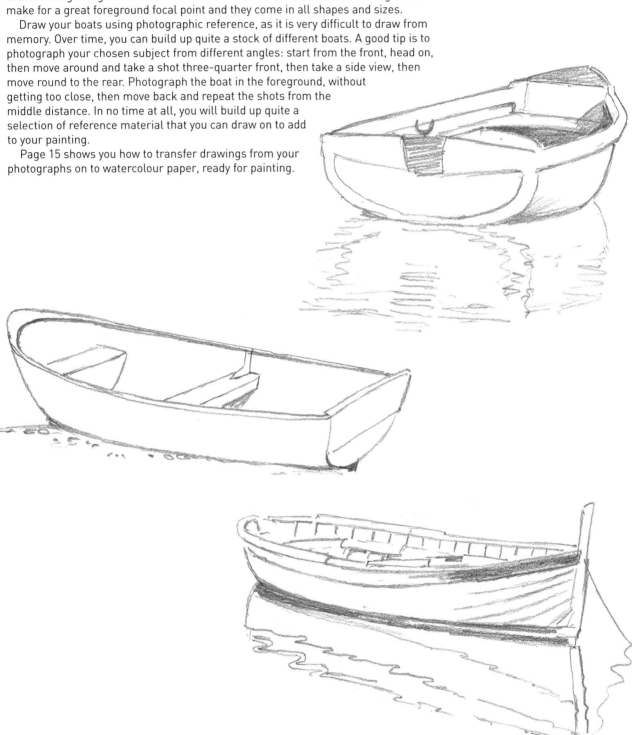

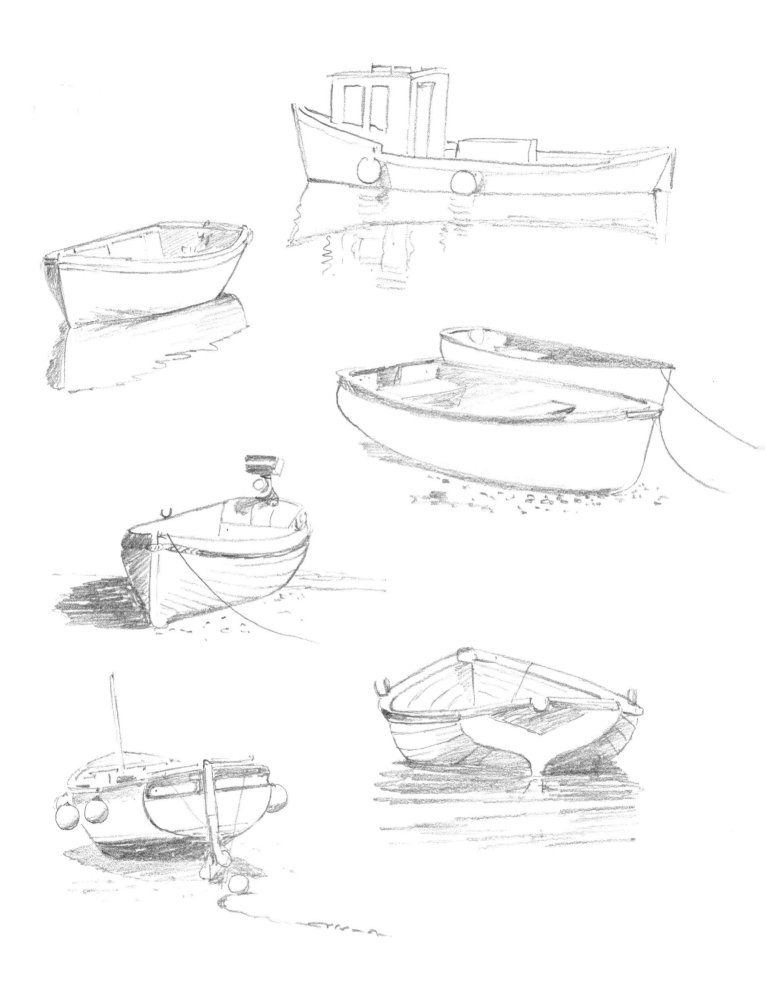

A simple scene

Take small steps until you get your sea legs; try a simple boat using a limited palette of just three colours and three brushes.

1 Draw the scene and use the medium detail brush to paint the hull with a wash of cobalt blue.

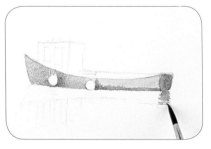

2 Use a stronger mix of cobalt blue to paint shade beside the fenders, at the waterline and on the stern, then paint in a rippled reflection of the stern with horizontal brush strokes.

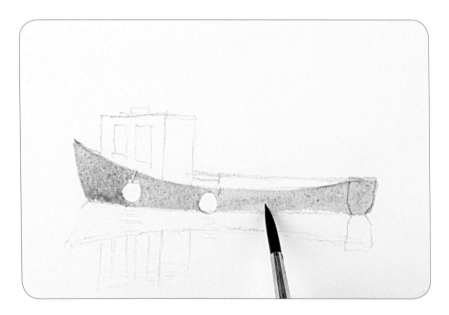

3 Add a little burnt umber to cobalt blue and paint the dark areas and windows of the wheelhouse, then the shaded inside of the boat, leaving white for the gunwhale.

4 Use the edge of the 13mm (½in) flat brush with cobalt blue to paint rippled reflections below the boat, leaving a strip of white for the water surface.

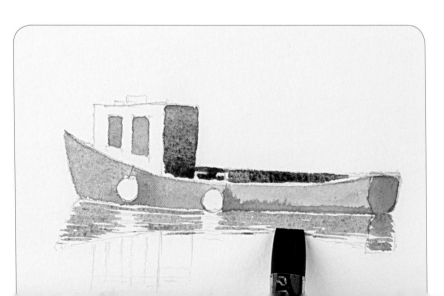

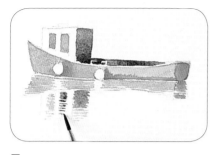

5 Use the small detail brush with a mix of cobalt blue and burnt umber to paint horizontal brush strokes to represent the rippled reflection of the dark parts of the wheelhouse.

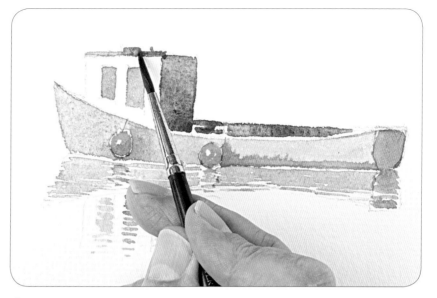

6 Paint the fenders and their reflections in cadmium red, then add the top of the wheelhouse with the cobalt blue and burnt umber mix.

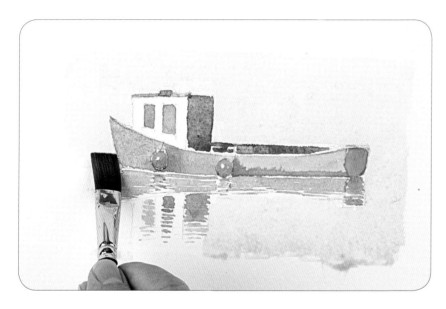

7 Make a dilute wash of cobalt blue and use the 13mm (½in) flat brush to paint the sky and the sea, painting carefully around the dried boat and reflection.

The finished scene.

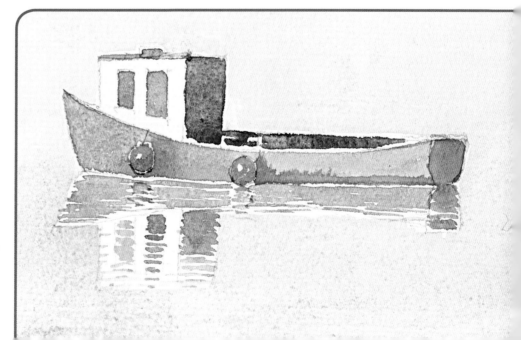

Reflections

Still water

Reflections are not just mirror images; they can be very deceptive. For example, when you are looking down on a boat, the reflection visible in the water is the underside of the boat, which you cannot actually see, so be sure to paint what you see, not what you think you see.

You will need

Colours: ultramarine blue, midnight green, raw sienna, cobalt blue, burnt umber

Brushes: 19mm (¾in) flat, large detail, small detail

1 Draw the boat and use the 19mm (¾in) flat brush to wet the paper around it with clean water. Paint horizontal strokes with a wash of ultramarine blue to suggest the sky and water.

2 Mix ultramarine with midnight green and paint this in horizontal strokes at the bottom of the painting, while the first wash is still wet. Paint horizontal ripples at the edge of the darker area. Allow to dry.

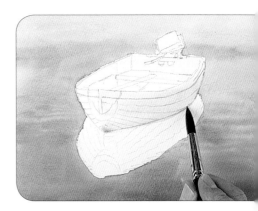

3 Wet the hull of the boat with clean water, then add a touch of raw sienna, with the large detail brush. Drop in a pale wash of cobalt blue lower down to create form.

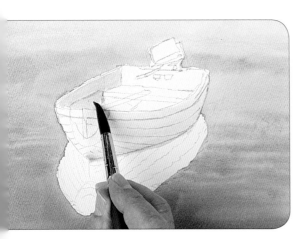

4 Paint the cobalt blue and raw sienna mix on the shaded parts of the boat inside, leaving the seat white.

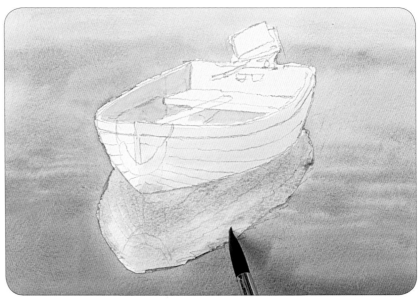

5 Wet the reflection area with clean water and drop in pale raw sienna wet into wet, then drop in the cobalt blue and raw sienna mix in the same way.

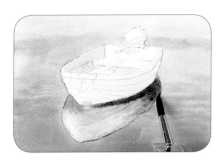

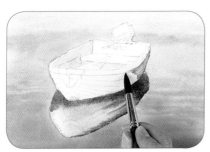

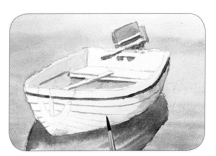

6 Still working wet into wet, drop in a darker mix of ultramarine and burnt umber round the bottom of the boat.

7 Add dark areas to the boat itself with the same mix and allow to dry.

8 Use the small detail brush to paint dark details of the boat with a mix of ultramarine and burnt umber. Darken the area under the seat.

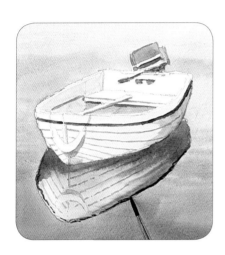

9 Suggest detail in the reflection with the same mix, then use a stronger mix to paint the reflection of the dark gunwhale. Break up the edges to suggest a slight ripple.

10 Paint a pale wash of raw sienna on the seat.

The finished scene.

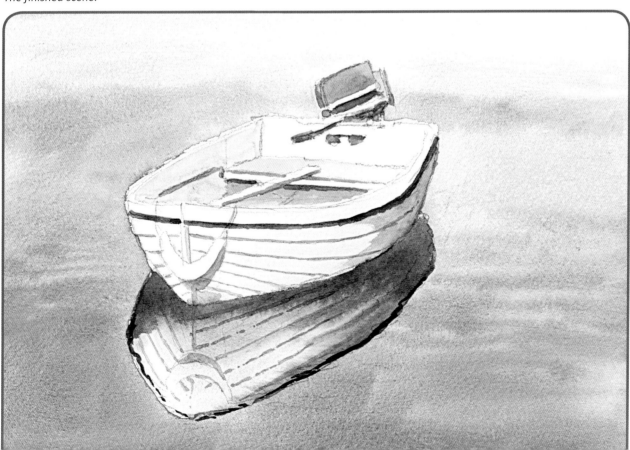

Rippled water

When the breeze picks up and ruffles the surface of the water, the reflections are distorted. Ripples are simply a series of short horizontal brush strokes placed together to create the reflected image of the boat.

You will need

Colours: ultramarine blue, burnt sienna, raw sienna, cobalt blue, midnight green, burnt umber, white gouache

Brushes: large detail, medium detail, 19mm (¾in) flat

1 Draw the boat and its reflection, then use the point of the large detail brush and a strong mix of ultramarine to paint the hull and stern. Drop in ultramarine and burnt umber lower down while this is wet.

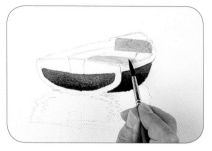

2 Use the medium detail brush to paint a paler mix of ultramarine and burnt sienna for the shaded parts inside the boat.

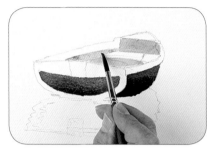

3 Paint on a mix of raw sienna for the inside of the boat hull.

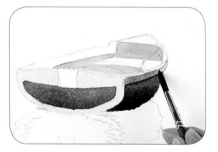

4 Make a pale mix of cobalt blue and burnt sienna and paint the shadow on the stern, then use a darker mix of the same colours to paint the shaded part of the gunwhale.

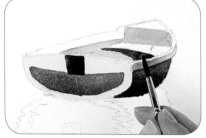

5 Paint the dark detail on the stern and the shadow under the seat with a mix of ultramarine and burnt umber.

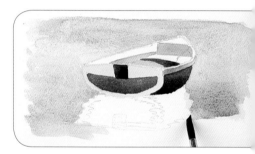

6 Use the large detail brush to paint a wash of cobalt blue around the boat and its reflection. Paint in horizontal strokes.

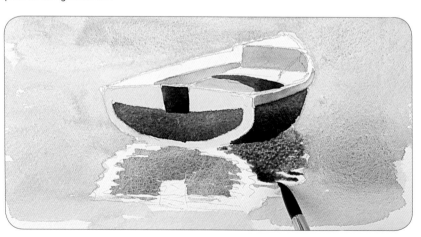

7 Paint the reflection of the stern using a mid-toned mix of ultramarine. Ripple the edges to suggest movement in the water. Then paint the reflection of the shaded hull with a darker mix, again rippling the reflections. Allow to dry.

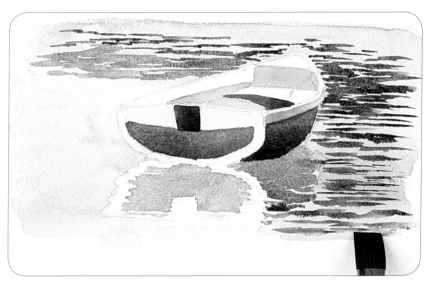

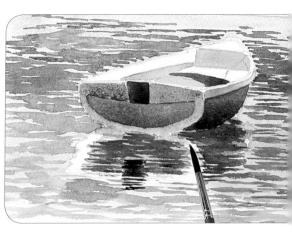

8 Use the 19mm (¾in) flat brush and a mix of ultramarine and midnight green to paint ripples around the boat. Add more midnight green to the mix as you come forwards.

9 Mix ultramarine with a little burnt umber and use the medium detail brush to paint the darkest ripples in the reflection of the shaded hull and the stern.

10 Use the 19mm (¾in) flat brush to paint the shapes of choppy water with ultramarine and midnight green, using a side-to-side motion.

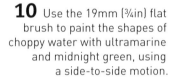

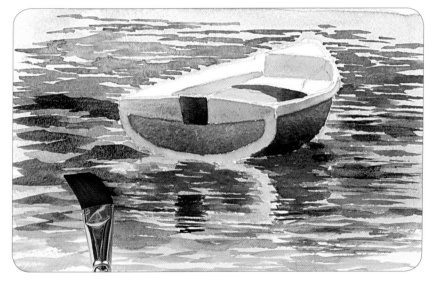

The finished painting. I added a little white gouache to lighten the white details of the stern and reflection.

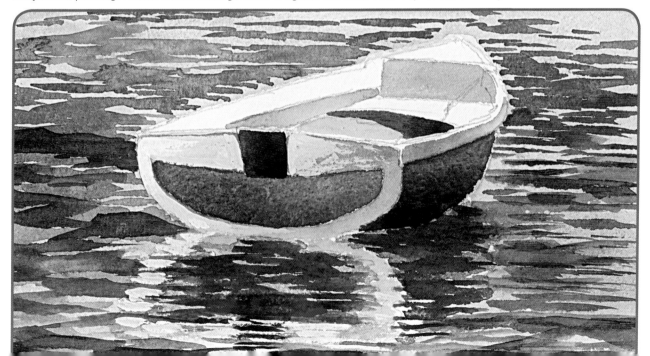

Harbours

Here is a selection of some of my favourite harbours. I travel extensively in search of painting subjects, and more often than not, I find myself at the coast.

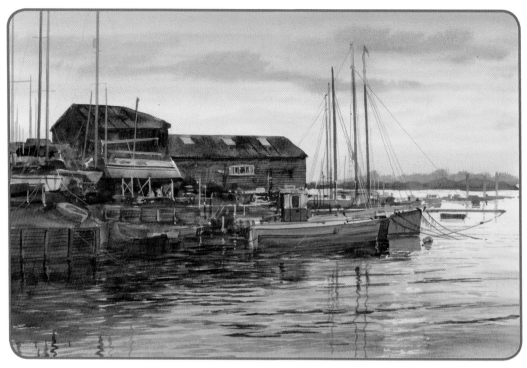

All Quiet at the End of the Day
A stunning view from the yacht club; this scene has lovely dark areas with subtle colour changes, giving the painting interest.

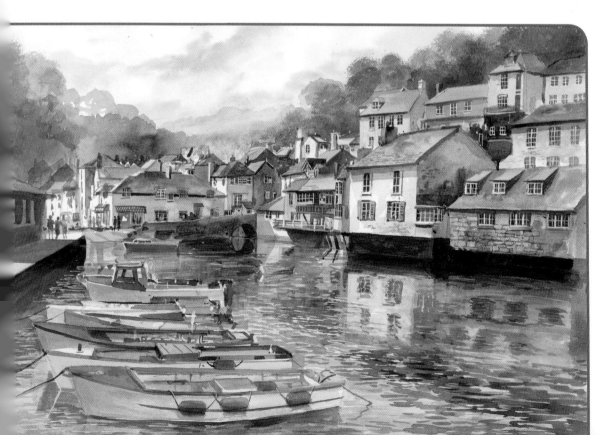

The Inner Harbour

In this scene there are misty trees in the background, a jumble of cottages on the quayside and buildings reflected in the water, and all the boats are lined up ready for the stream of tourists. With such a panoramic view, there are lots of windows. Begin with the black rectangle, then use the half-rigger brush with some white gouache to paint each window frame.

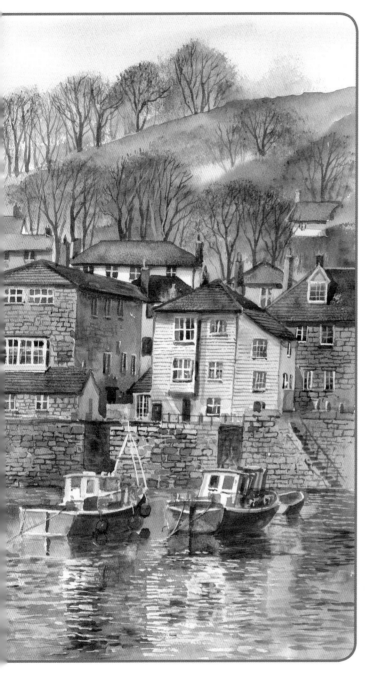

Winter Mooring

Harbours in the winter months can often be cold and grey, but when the sun comes out, everything changes. Adding the bare trees at the top of this painting signals the time of year.

On the Quay

Old working boats are much more appealing to paint than the white cruisers and speed boats often found in harbours. With a little imagination and some good reference photographs, the new can be replaced with the old. This way the landmarks of the quayside remain the same, but the boats have more painter appeal.

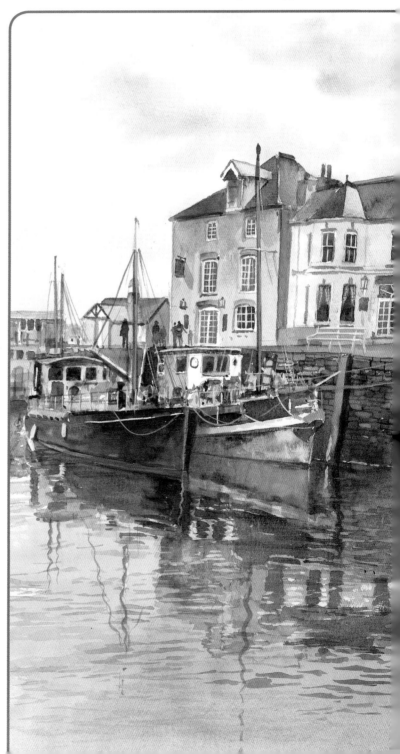

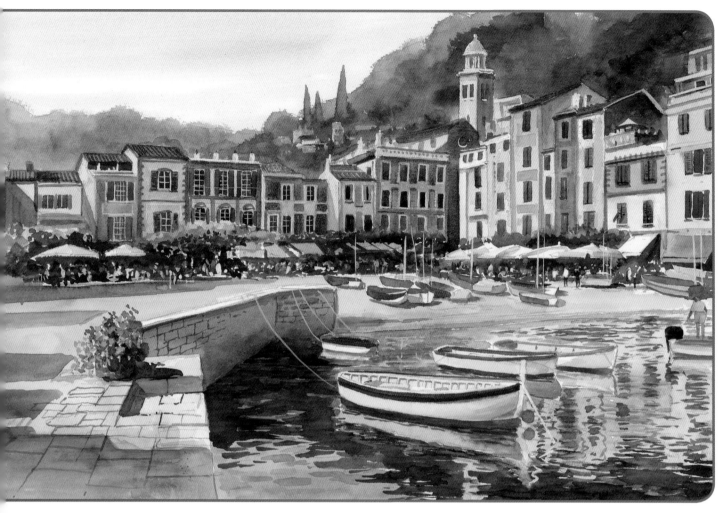

Mediterranean Harbour

A happy holiday painting, full of warm colours and reflecting fond memories of summers past.

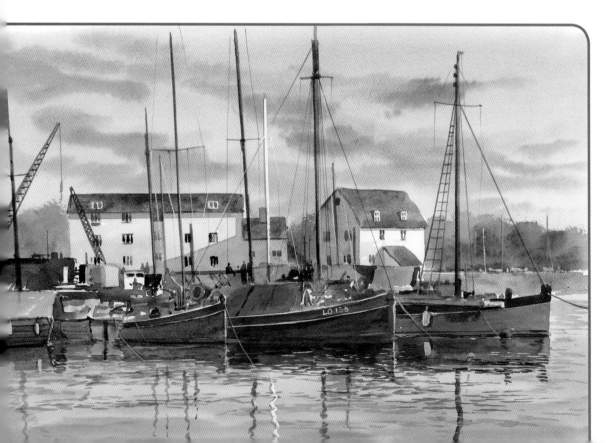

The Tide Mill

In this Woodbridge scene, the early morning light catches the white clapperboard mill in the background while the working boats line up, waiting for some attention from the boat repair yard.

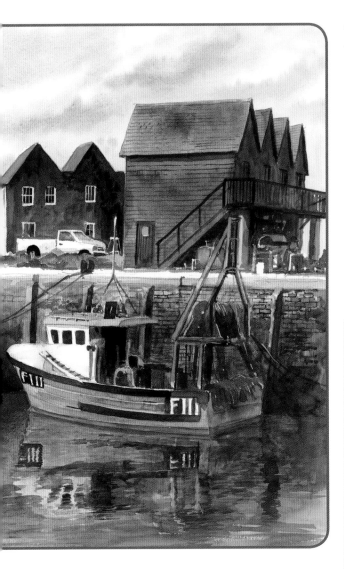

The Harbourside

The fisherman's black sheds dominate the quayside in this busy working harbour. The darks of the sheds on the left contrast strongly with the lighter, warmer greys of the larger sheds on the right. I used ultramarine and burnt umber for all of the buildings but dropped in some raw sienna whilst the colour was still wet, to lighten the darks on the lighter buildings. The harbour wall is also very dark and this helps to highlight the colourful fishing boat at its mooring.

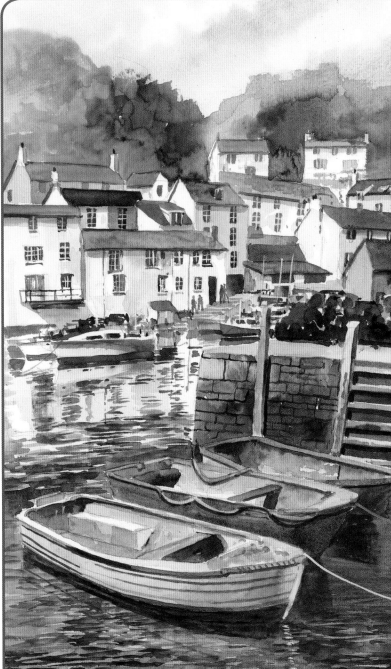

All in a Row

I like the composition of this painting, the focal point of this harbour scene is the boats in the foreground, the eye is then lead up the ladder on the quay, then across the water to the boats then upward to the cottages on the hillside opposite.

Rigging

Painting rigging that looks realistic and not heavy-handed is a skill, and with any skill, it needs practice and patience to get right. You need a brush such as the half-rigger, a long-haired brush that goes to a fine point, and a long straight edge such as a ruler.

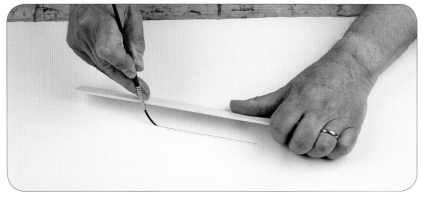

Hold the ruler at a 45° angle with your knuckles firmly on the paper and your thumb on the back of the ruler, supporting it. With your other hand, hold the brush ferrule (the metal bit) against the edge of the ruler and steady your hand by placing your finger on the front of the ruler, then slide the brush along the ruler edge with the tip of the brush just touching the paper.

Opposite

All Tied Up

The technique used for painting rigging is also used to paint masts and other straight lines. Masking fluid was used on the white masts, applied using a brush against a ruler.

Full Sail

Rigging features a lot when painting sailing boats. Care must be taken not to be too heavy handed; remember it's always easier to thicken a narrow line. The top of the sails has been cropped to make a more dramatic painting.

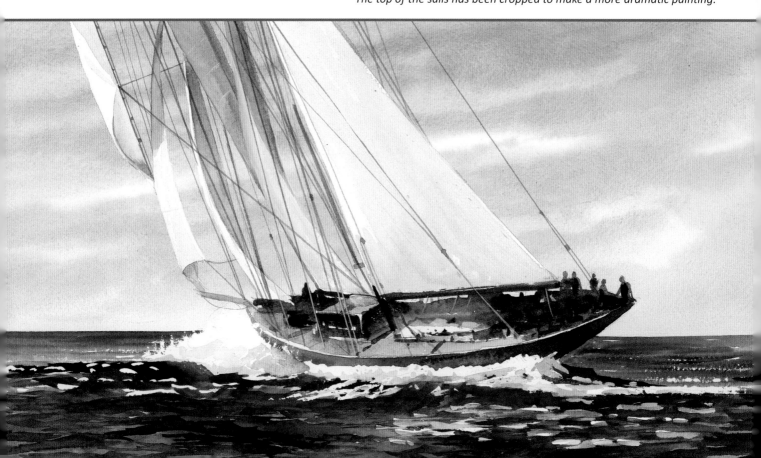

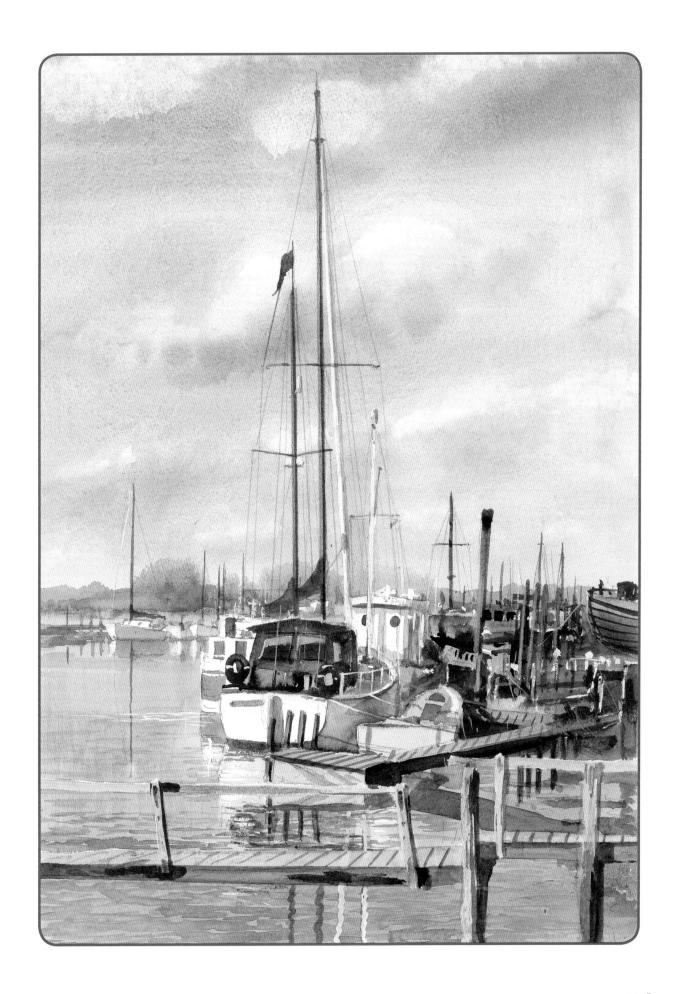

Setting sail

Painting simple sails

Painting sailing boats in watercolour takes some time and planning: the time is in the drying and the planning is needed when placing white sails against a dark background. When starting to paint, wet the sky area only, leaving the sails dry, then drop the sky colour into the wet area. The colour will only spread where the paper is wet, leaving the sails white. When the sky has dried, you can wet the sails and drop in a little colour.

You will need

Colours: ultramarine blue, burnt umber, midnight green, raw sienna, cobalt blue

Brushes: large detail, medium detail

1 Draw the sailing boat, then use the large detail brush to wash around the edges of the sail and boat with clean water. Paint the sky with ultramarine.

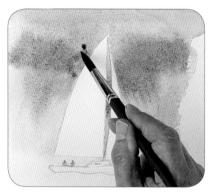

2 Mix ultramarine and burnt umber and drop this in to suggest clouds while the first wash is wet.

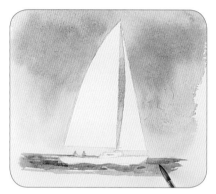

3 Paint the sea with ultramarine and midnight green, and add darker ripples with the medium detail brush.

The finished painting.

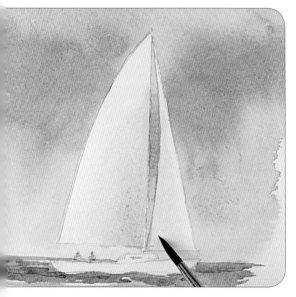

4 Paint clean water on the sail, then drop in a very pale raw sienna wash. While this is wet, drop in pale cobalt blue for shade.

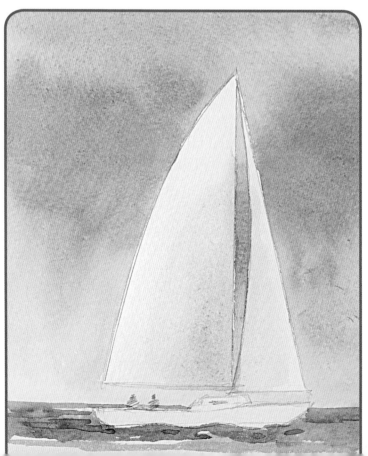

Masking fluid sails

Painting the sky behind a boat in full sail using watercolour is frankly difficult. The easy way is to cover the sails with a thin coat of masking fluid to protect them from any surrounding colour. You can then paint the background area freely, without fear of covering the sails. When the background is dry, the masking fluid is removed to reveal the white of the sails. Any rough edges can be tidied up with some white gouache.

You will need

Colours: ultramarine blue, burnt umber, midnight green

Brushes: large detail, small detail

Masking fluid, small masking fluid brush

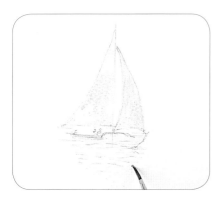

1 Draw the sailing boat, then use a small masking fluid brush to apply masking fluid to the sails, boat and rippled reflections in the water. Allow to dry.

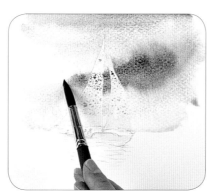

2 Wet the sky area and paint on an ultramarine wash with the large detail brush. While this is wet, drop in a cloud wash of ultramarine and burnt umber wet into wet, going over the sails.

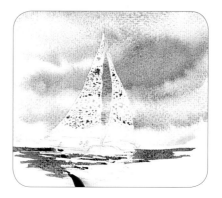

3 Paint the sea with horizontal strokes of ultramarine and midnight green, leaving gaps to suggest waves. Allow to dry.

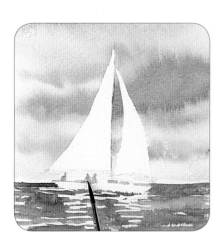

4 Rub off the masking fluid with clean fingers. Use a small detail brush to tidy up the edges of the masked area with a pale mix of burnt umber and ultramarine, and paint in the figures in the boat with the same mix.

The finished painting.

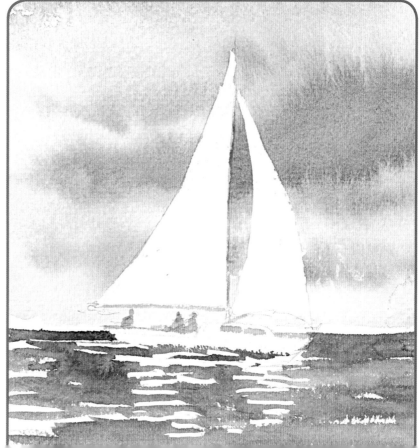

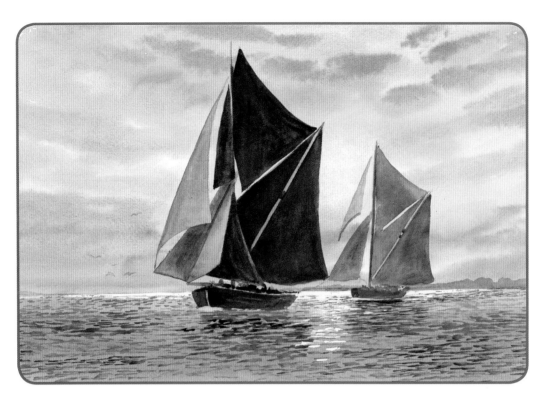

Sails at Sunset

Masking fluid was used not only on the water but also to mask some of the sails and masts. Dark sails can be painted over a lighter ground, but the lighter sails may need to be masked.

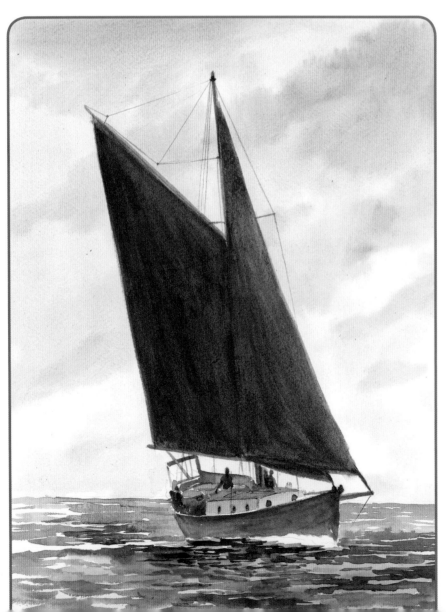

Hard at Work

Dark-coloured sails can make a striking contrast against a pastel-coloured sky. Use burnt sienna as the main colour and darken it with burnt umber and ultramarine. The sail colour is reflected in the water.

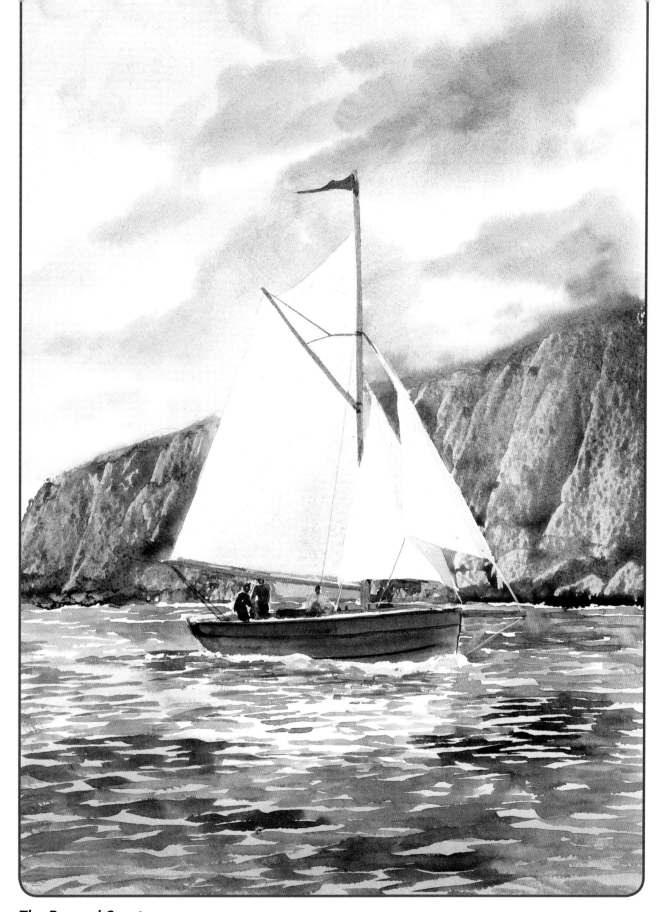

The Rugged Coast

*The backdrop of rugged cliffs helped to make the sailing boat stand out. The texture of the
cliff face was created by using a rough-surfaced paper and scraping the paint away with
a plastic card. Masking fluid was used to protect the shape of the sails.*

Abandon ship!

Choosing a subject to paint can be just as important as the painting itself. For example, the old hulk of an abandoned boat has lots of possibilities; sometimes a rustic boat can be more fun to paint than a fully restored vessel. The looser the painting, the more rustic the boat.

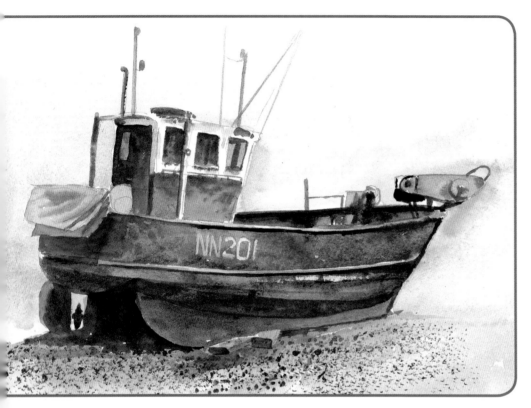

This old trawler has seen better days but all it needs is a lick of paint and a little tender loving care to bring it back to its glory days. As a subject to paint, it's perfect as it is. The rust on the hull is painted wet into wet, starting with a wash of ultramarine then dropping some burnt sienna and raw sienna into the wet paint and letting it do its magic. The lettering was added using white gouache.

Opposite

The old Thames barges moored in the distance provide an interesting backdrop for this study of a forgotten rowing boat. The washes of green over the rear of the boat give a real sense of decay and neglect, and the mooring ropes with the hanging seaweed lead the eye to the stranded boat which forms the focal point of the painting.

For some people, the rear end of an old Thames barge is the perfect subject to paint; to others it's just a wreck. The green slime and seaweed hanging from the ropes have a certain appeal, if you like that sort of thing.

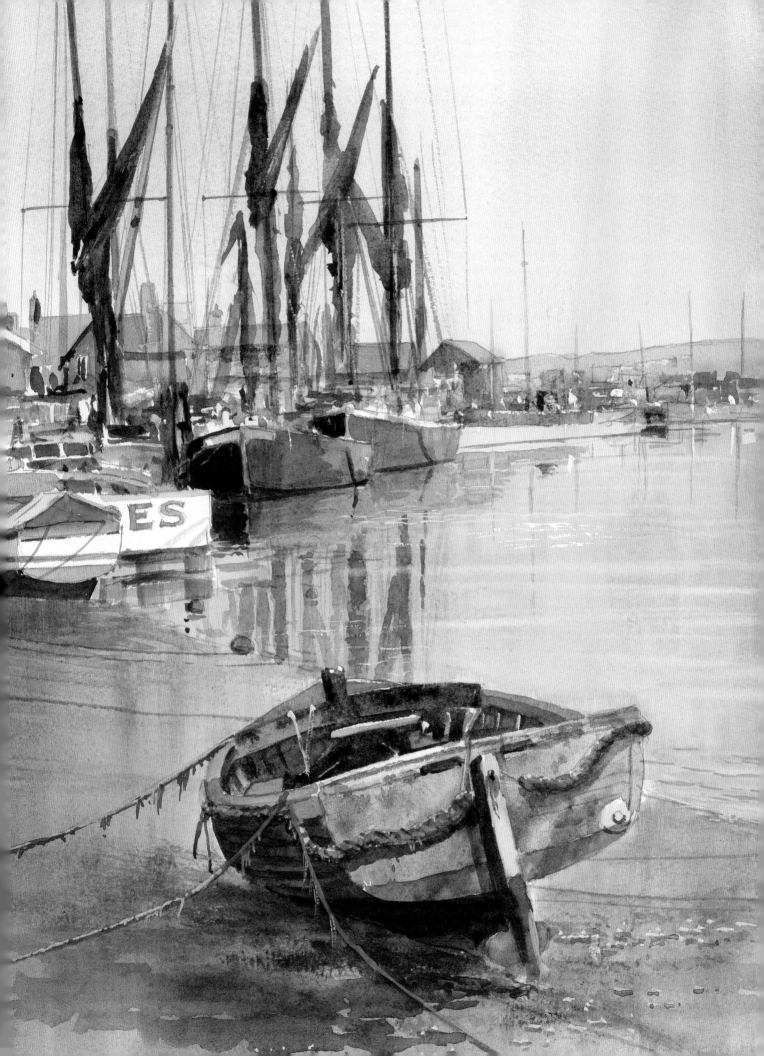

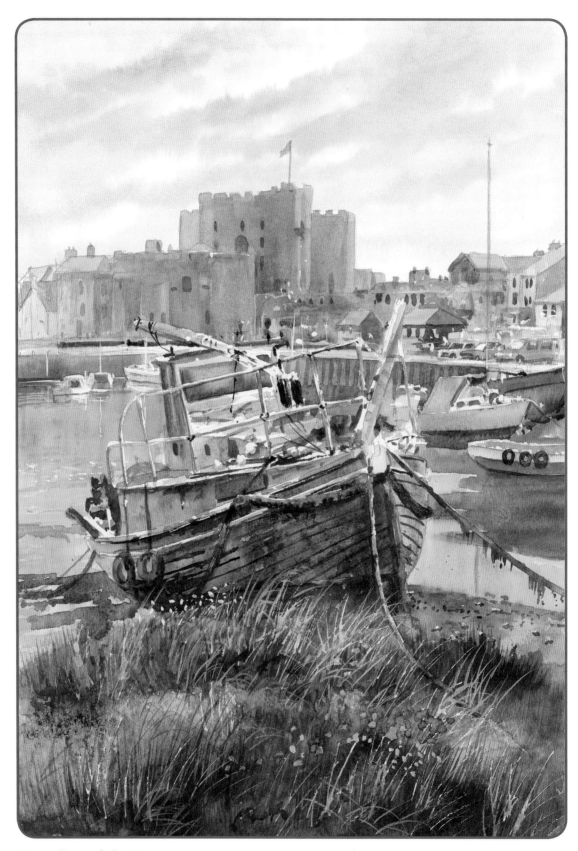

Guardian of the Keep

This historic harbour provides an apt backdrop for an old hulk which is fast becoming history itself.
Masking fluid was used to great effect on the deck railings and the mooring ropes. The marsh grasses
and flowers in the foreground were also masked and provide a splash of colour to brighten the shoreline.

One Careful Owner

This old-timer is high and dry in the last chance boatyard. Once someone's pride and joy, this scruffy little sea urchin is in for a refit. The peeling paint on the bow is masked using masking fluid and the rust colours are burnt sienna, cadmium yellow and burnt umber. The wheelhouse window has orange paint dropped into the mix of ultramarine and burnt umber. Care must be taken when painting the planking on the sides of the boat; if the detail is too loose, it won't look realistic. The paintwork can look distressed, but the actual structure should be sound.

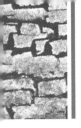

On the waterfront

Most harbours have a harbour wall or jetty and they all have a very individual and distinctive style. Take time to study the stonework before painting it. Here are two techniques to get you started.

Harbour walls and quays

Scraping out with a brush handle

This technique is simple and very effective, but it does need some practice. Put the base colour on first using a damp brush. Squeeze the water out of the brush with your fingers, as if it is too wet, it will not work! The same applies to the dark top coat, but this top layer is much thicker – thick enough to be scraped away like a snowplough, pushing the paint to one side to form an outline for each stone.

You will need

Colours: raw sienna, sunlit green, burnt umber, ultramarine blue
Brush: foliage px
Paper mask

1 Wet the foliage brush and squeeze it so it is just damp. Pick up raw sienna and, using a paper mask to mask the top of the wall, stipple on the wall area beneath it.

2 Mask the bottom of the wall and stipple sunlit green over the lower part of the wall, wet into wet.

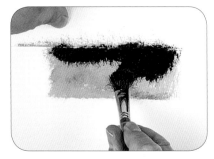

3 Mask the top of the wall and stipple on a thick, dark mix of burnt umber and ultramarine blue.

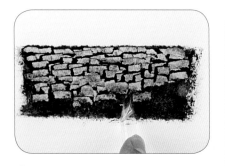

4 While the paint is wet, use the end of the brush, in this case a specially made acrylic resin handle, to scrape out the shapes of stones in the wall.

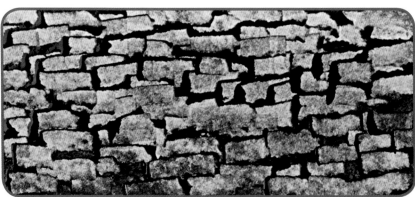

The finished wall.

Stippling texture

This is a simple way of painting a textured harbour wall using the foliage brush and a half-rigger brush. The colours of the wall are stippled first to create the texture and the stonework is picked out and outlined using the half-rigger.

You will need

Colours: raw sienna, ultramarine blue, burnt umber, country olive
Brushes: foliage, half-rigger

1 Stipple on raw sienna with the foliage brush to create the shape of the wall.

2 Stipple a mix of ultramarine blue and burnt umber on top.

3 Mix country olive and burnt umber and stipple this on top. Allow to dry.

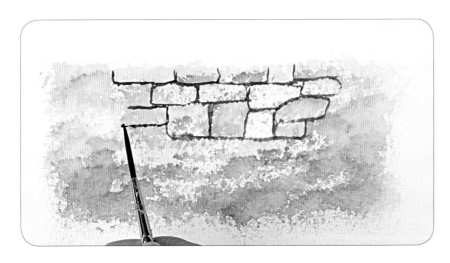

4 Use the half-rigger and a mix of burnt umber and ultramarine to paint crevices between the stones.

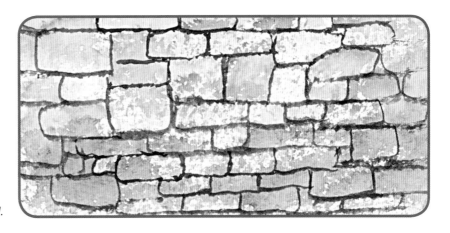

The finished wall.

Piers and jetties

Boats are not the easiest craft to get in or out of. That's why we have piers and jetties which protrude out into the water. They not only keep our feet dry, but also make fine subjects to paint.

You will need

Colours:
 ultramarine blue, burnt umber, country olive, raw sienna

Brushes: golden leaf, 19mm (¾in) flat, medium detail, 13mm (½in) flat, half-rigger

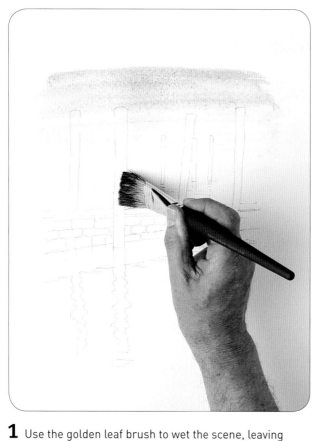

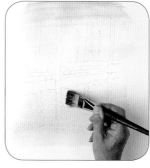

2 Apply the same wash of ultramarine from the bottom of the scene, working your way upwards. This body of water will reflect the wall.

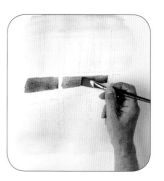

3 Using the 19mm (¾in) flat brush, paint the area of the wall with a mix of burnt umber and country olive. Leave the posts white.

1 Use the golden leaf brush to wet the scene, leaving the top of the wall dry. Apply a wash of ultramarine blue, fading from the top.

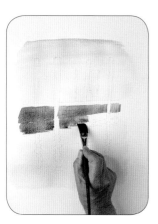

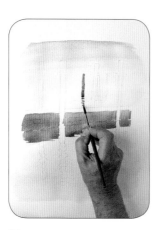

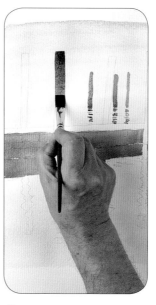

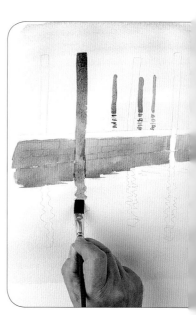

4 Create the reflections of the wall using downward strokes. Leave to dry.

5 Using the medium detail brush, create downward strokes for the posts, and move the brush from side to side to create ripples.

6 Switch to the 13mm (½in) flat brush and paint the thicker posts into the scene using more downward strokes.

7 Paint the reflections of the posts in the water beneath, using the flat tip of your 13mm (½in) brush to create a wiggling motion.

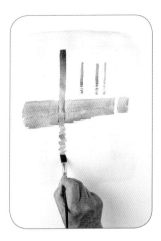

8 Continue to paint wiggles to create reflections for the posts.

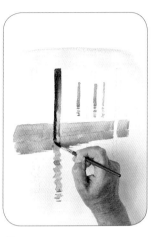

9 While the painting is still wet, make the burnt umber and country olive mix darker and stronger, adding it to the left-hand side of the posts for shade.

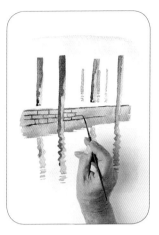

10 Using a half-rigger brush and the darkened mix of burnt umber and country olive, paint in the details of the brickwork.

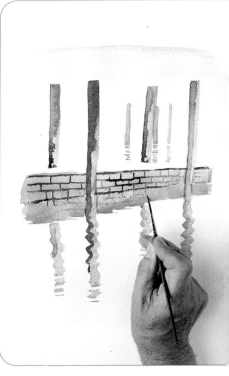

11 Paint faint, broken lines to create detail in the reflection.

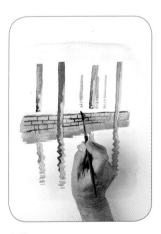

12 Using a pale mix of raw sienna, burnt umber and country olive, paint in the detail for the top of the wall.

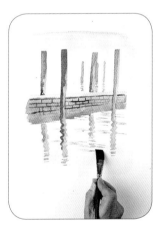

13 With a 19mm (¾in) flat brush, use ultramarine to paint ripples across the water.

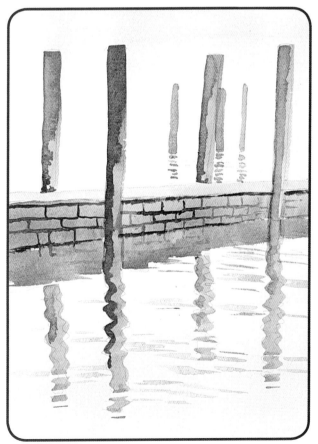

The finished painting.

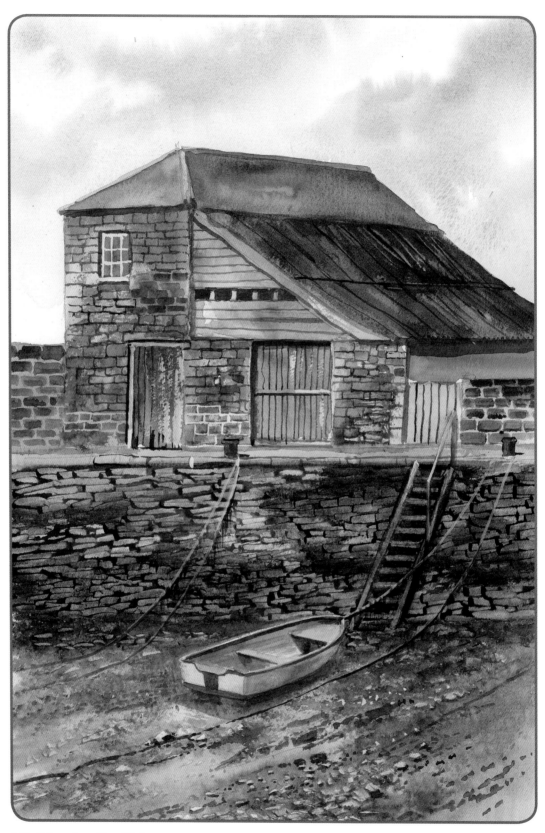

Waiting for the Tide

In this painting the scraping out technique was used on the harbour wall and the stones on the shoreline. For the stonework on the buildings a more conventional approach was used: a wash first followed by stippling for the texture, then once this was dry, each stone was carefully outlined using the half-rigger brush with burnt umber and ultramarine.

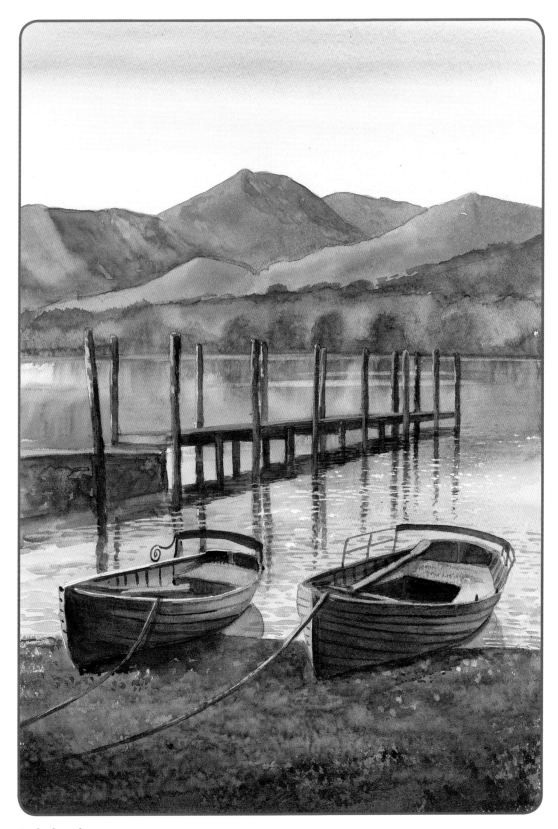

Lakeland Boats

The wooden jetty forms a perfect link between the boats on the shoreline and the distant hills. Masking fluid was used on the jetty posts, the ripples in the water and the mooring ropes. The composition of the painting has a strong zigzag to it, following the ropes to the boat, moving up to the jetty and then across the lake towards the hills unfolding into the distance.

Jetty at Low Tide

The main components of this painting are the two boats at the water's edge and the cluster of fisherman's cottages beyond the sea wall. The jetty forms a perfect link between the two halves of the painting. The water is lapping gently on to the shore, but is ruffled enough for a few rippled reflections beneath the boats and the posts on the jetty.

You will need

Colours: ultramarine blue, country olive, raw sienna, burnt sienna, shadow, burnt umber, sunlit green, country olive, cobalt blue

Brushes: golden leaf, medium detail, foliage, large detail, 13mm (½in) flat, half-rigger

Scrap paper for mask

1 Draw the scene. Wet the sky and sea areas with the golden leaf brush, going round the buildings and the boats. Brush in the sky shapes, leaving dry paper for clouds. Drop a wash of ultramarine blue into the wet areas.

2 Brush the ultramarine blue wash downwards for the reflection in the water, working round the boats. Allow to dry.

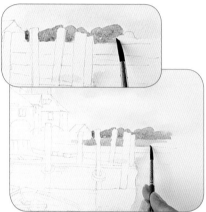

3 Use the medium detail brush and a mix of ultramarine blue and country olive to paint the far distant trees, painting carefully round the posts. Add raw sienna to the mix and paint the distant fields.

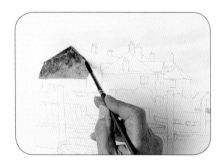

4 Begin to block in the buildings with a mix of burnt sienna and a touch of ultramarine. Drop in shadow colour while the first wash is wet.

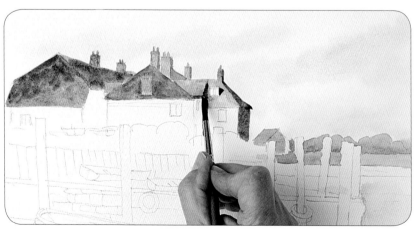

5 Block in all the buildings in the same way and drop in shadow wet into wet. Allow to dry, then use a mix of shadow and burnt sienna to add darker details.

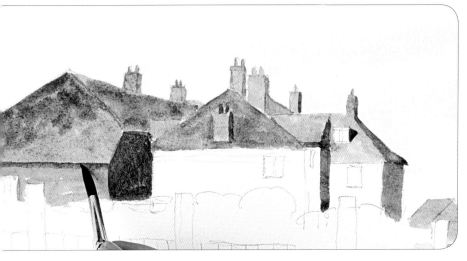

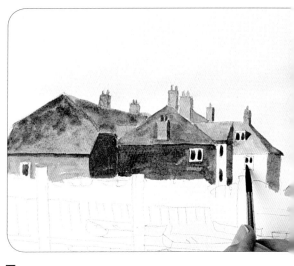

6 Add more burnt sienna to the mix to paint the shaded sides of the buildings, then continue adding darker details with the same mix.

7 Mix burnt umber and ultramarine and paint the dark front of one building, then the darks of the windows. Add chimney pots and other details.

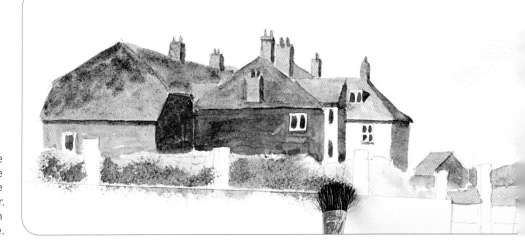

8 Use the foliage brush and a pale mix of sunlit green to stipple foliage in front of the buildings. Mask the sea wall below this with scrap paper. While this is wet, stipple lower down with country olive.

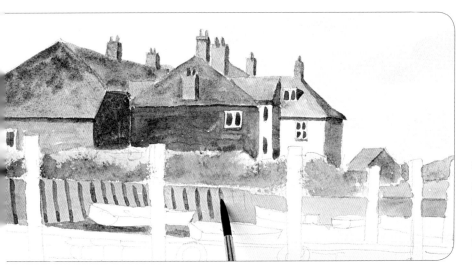

9 Paint the sea wall with the medium detail brush and a pale mix of ultramarine and burnt umber, working around the boats. Allow to dry. Add the woodwork and the darks under the boats with a darker mix of the same colours.

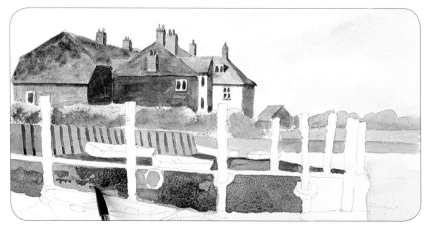

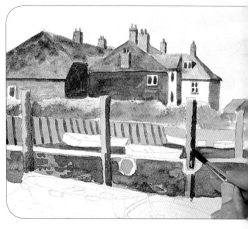

10 Use the large detail brush to block in the pier with a mix of country olive and burnt umber, then drop in a darker mix of the same colours, wet into wet.

11 Paint the posts with the medium detail brush and a pale mix of raw sienna and country olive. Allow to dry and paint the shaded right-hand sides with a darker mix.

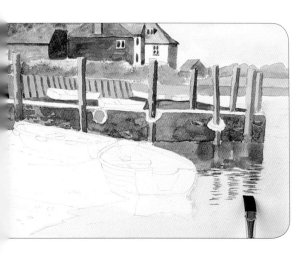

12 Use same mix and the 13mm (½in) flat brush to paint the reflection of the pier, then add horizontal strokes with the edge of the brush to indicate rippled reflections.

13 Mix ultramarine with a little burnt umber to paint the tyres.

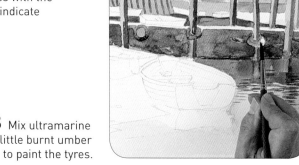

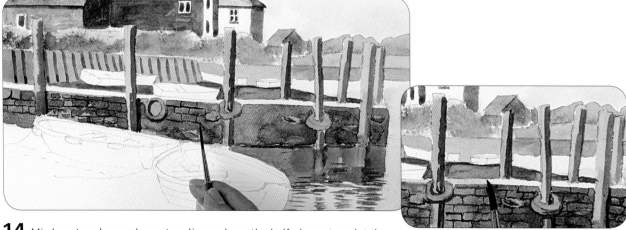

14 Mix burnt umber and country olive and use the half-rigger to paint the brickwork of the pier. Change to the medium detail brush and paint a pale wash of country olive and burnt umber along the top of the pier.

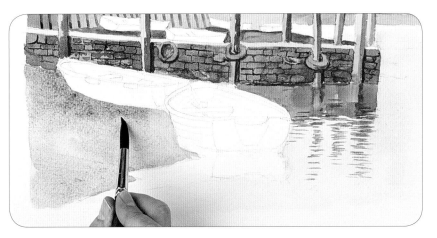

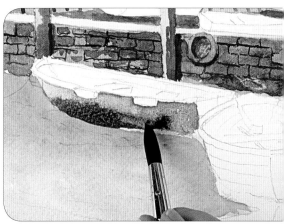

15 Use the large detail brush to wash a pale mix of ultramarine with a touch of burnt umber on the shore, then drop in burnt umber wet into wet, making it darker around the boats. Allow to dry.

16 Block in the left-hand boat with ultramarine, painting round the details, then drop in a dark mix of ultramarine and burnt umber at the bottom, wet into wet, so that the colour spreads upwards. Allow to dry.

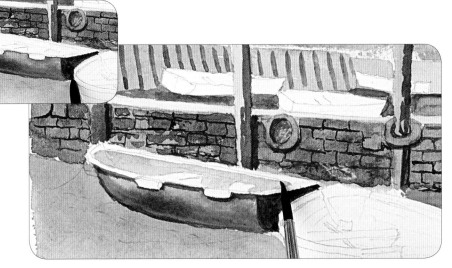

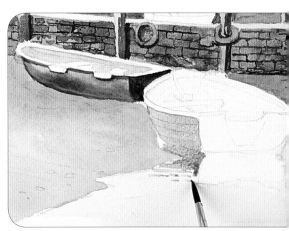

17 Paint the stern of the boat with a dark mix of ultramarine and burnt umber, then use the medium detail brush to paint the inside of the boat with a very pale mix of the same colours.

18 Paint the other boat with cobalt blue and put in the reflection and rippled reflection at the same time.

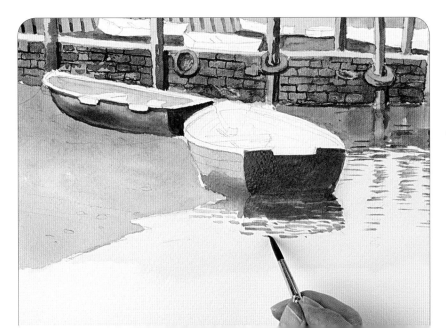

19 While this is wet, paint a dark mix of cobalt blue and burnt umber at the bottom of the boat. Allow to dry, then use the same mix to paint the stern of the boat and its reflection. Break the reflection up into little horizontal ripples at the bottom.

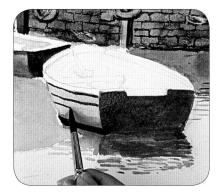

20 Darken the boat at the waterline with the same mix and add planking.

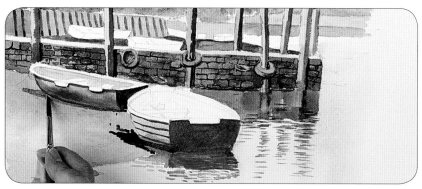

21 Use burnt umber with a touch of ultramarine to paint shadows on the shore under the boats. Paint under the distant boats with the same mix to define them.

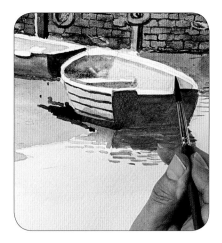

22 Paint the inside of the right-hand boat with a pale mix of raw sienna and drop in a dark mix of burnt sienna and shadow for the darks, wet into wet.

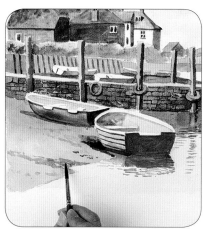

23 Use a mix of ultramarine and burnt umber to paint the hulls of the more distant boats, then paint the texture of the shingle with a greyer mix of the same colours.

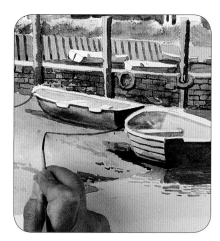

24 Change to the half-rigger to paint the mooring lines of the boats with the same grey mix.

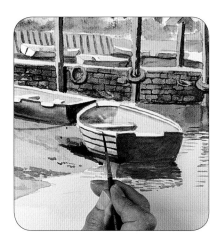

25 Add detail to the foreground boats with the same brush and mix. Paint the insides of the distant boats, some with the grey mix and some with pale raw sienna.

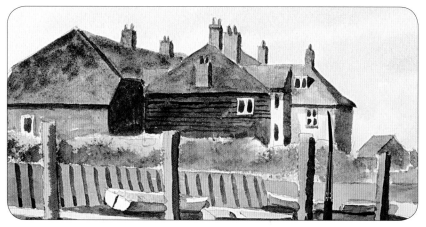

26 Paint detail such as weatherboarding on the buildings with a dark mix of ultramarine and burnt umber. Finally add shadows on the white parts of the buildings using cobalt blue.

The finished painting.

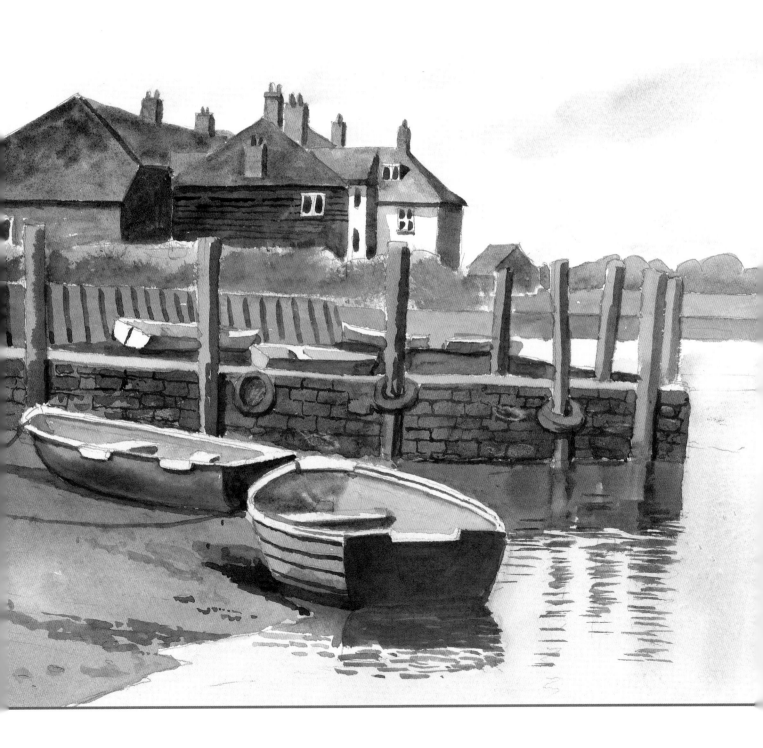

Boatyard clutter

There is always something going on in a boatyard, accompanied by the sounds of sanding, scraping, drilling and hammering.

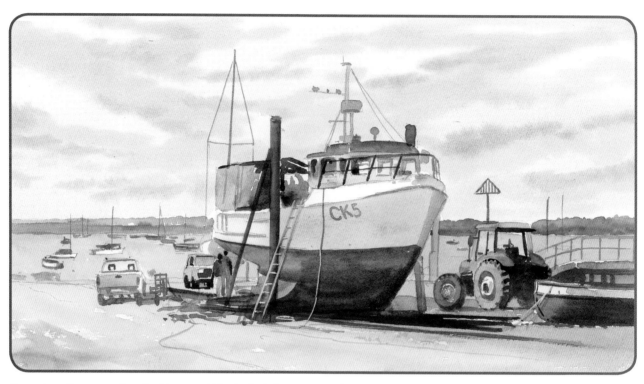

To capture the sense of scale, it's a good idea to include some people, cars or even a tractor.

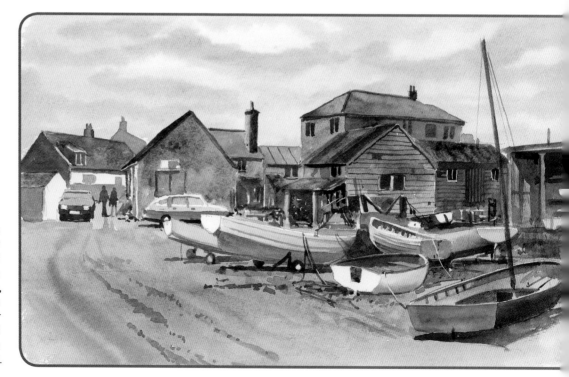

Some boatyards seem very cluttered; indeed some are a bit of a tip, like my studio, where there is a place for everything and I know where everything is.

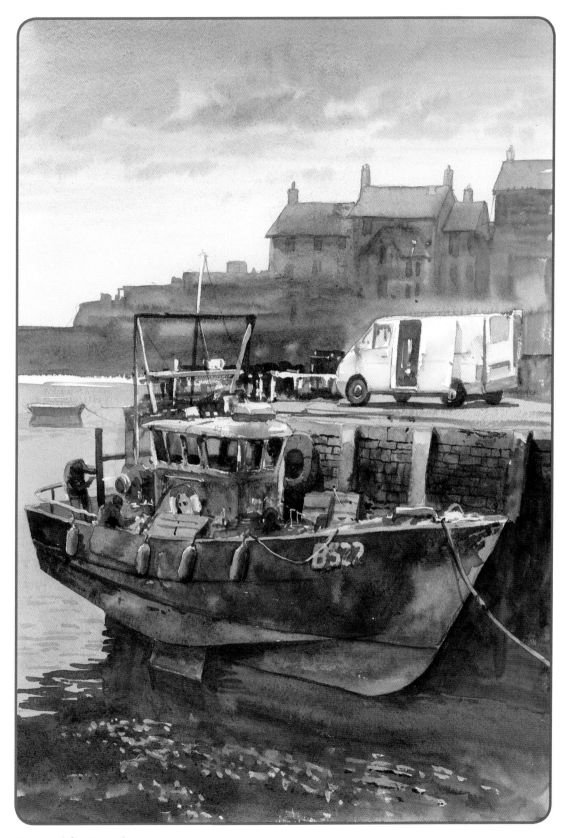

Quayside Repair

There is lots going on in this painting, not just with the workman but all the clutter on deck. The wet into wet technique is a gift for painting this boat's hull: wet the whole hull with clean water, then drop in cadmium red. The fun starts when you begin to add the rust colours into the first wet colour and just let it blend on the paper.

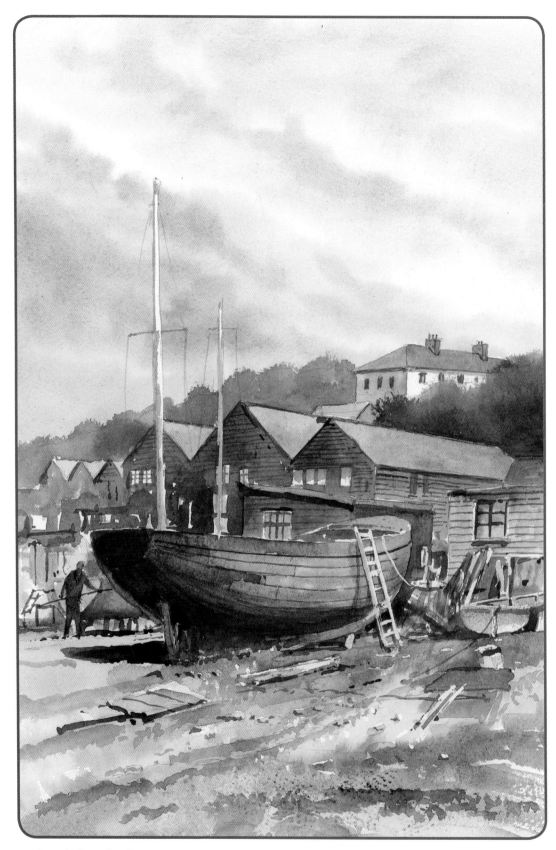

Behind the Sheds

This is another busy subject with the black sheds in the background and the general mess of debris scattered around the boatyard, but the detail on the boat is very clear. It's the yard that is a mess, not the boat!

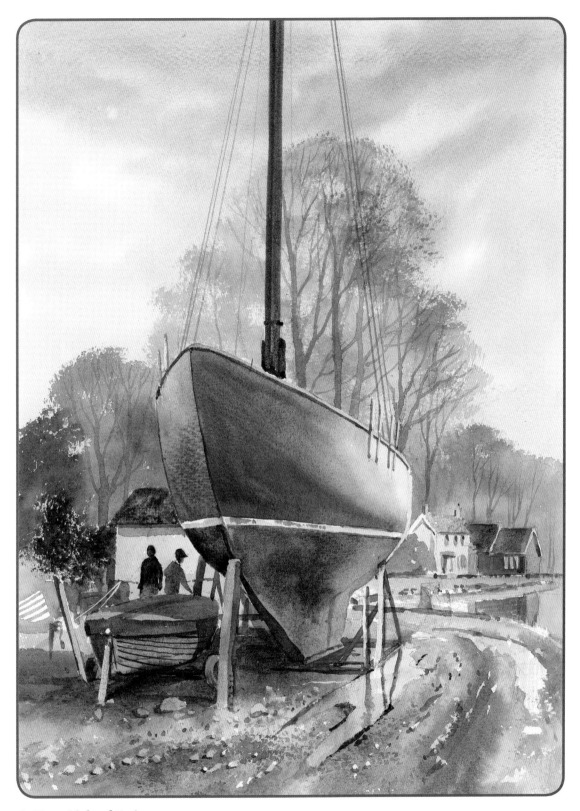

A New Lick of Paint

There's more to a boat out of water than meets the eye; the shape of the keel is a work of art in itself. This yacht is about to get a new paint job, and some would say it's easier to paint the real thing than try to capture its beauty in watercolour. The boat in the yard would be painted in sections in the same way as you would approach a watercolour. In the painting, the boat is divided into four sections, and I paint one quarter at a time, wet into wet, beginning with the lightest part.

Beaches and estuaries

Where the land meets the sea, there are lots of interesting beaches and estuaries scattered along the coastline, with lovely boats waiting to be painted.

Shingle beach

The easiest way to paint a shingle beach is to stipple the texture using a foliage brush rather than using a wash brush. The lighter stones are masked with masking fluid.

You will need

Colours: raw sienna, burnt sienna, burnt umber, ultramarine blue
Brushes: foliage, small detail
Masking fluid and masking fluid brush

1 Use a masking fluid brush to dot masking fluid on to the beach area to create texture. Allow to dry.

2 Pick up a thick mix of raw sienna on a damp foliage brush and stipple texture over the dried masking fluid. Allow to dry.

3 Stipple burnt sienna on top and allow to dry.

4 Dot in stones with the small detail brush and a mix of burnt umber and ultramarine and allow to dry. Remove the masking fluid with a clean finger.

The finished shingle.

Opposite

On the Beach

This is the life! When they have finished work, some boats spend the day just sitting on the beach. Some fishing fleets don't have a harbour, so at the end of the fishing trip they are hauled high and dry on the beach by tractors and winches. It's an impressive sight to see these magnificent boats perched high on the shore.

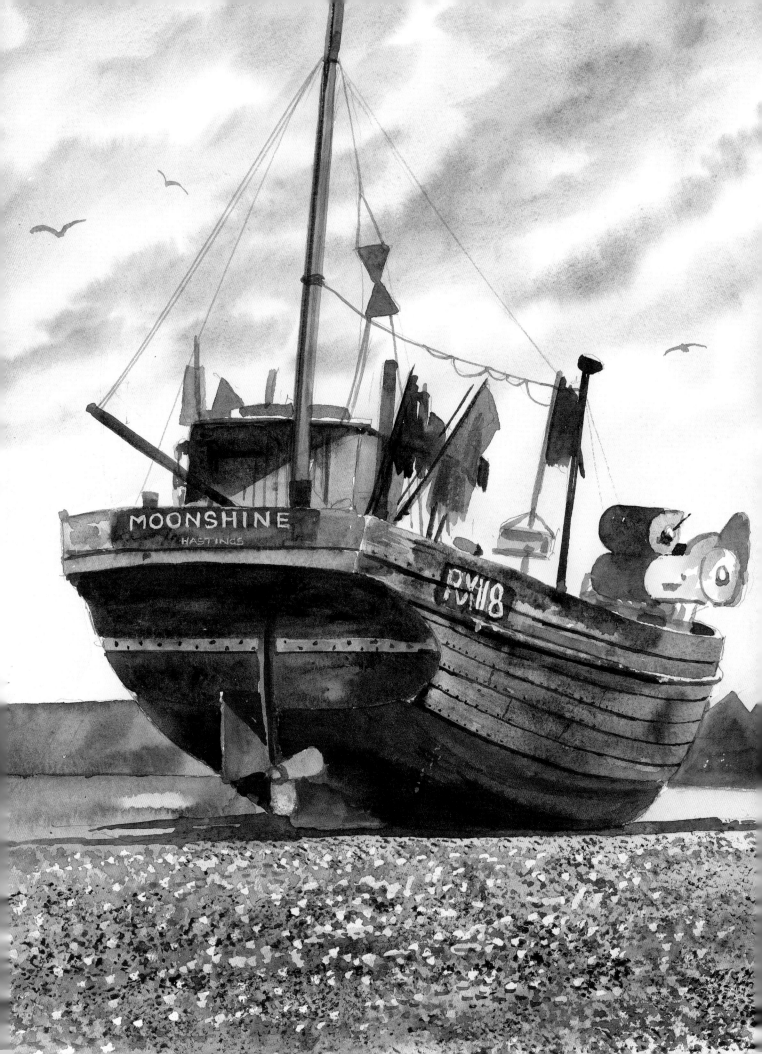

Beached boat

This is a simple project to get you started painting boats. Boats don't always have to be in water to get you rushing for your paints; they make an equally appealing subject marooned on beaches and mud flats.

You will need

Colours: raw sienna, burnt sienna, burnt umber, cobalt blue, ultramarine blue, shadow

Brushes: foliage, medium detail

Masking fluid and masking fluid brush

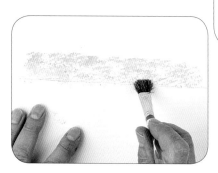

1 Draw the boat, then use a paper mask over the top to protect it while you stipple raw sienna over the shingle beach, using the foliage brush.

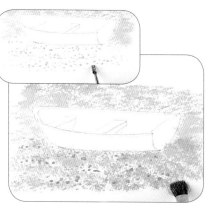

2 Apply dots of masking fluid over the foreground area of shingle using the masking fluid brush and allow to dry. Stipple raw sienna with a touch of burnt sienna over the top with the foliage brush. Allow to dry.

3 Stipple burnt umber over the top, allow it to dry, then rub off the masking fluid with a clean finger.

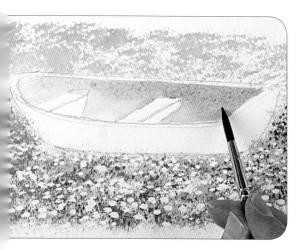

4 Use the medium detail brush and a mix of cobalt blue and a touch of raw sienna to paint the inside of the boat, leaving the seats white.

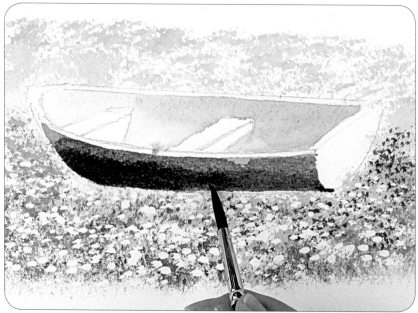

5 Paint the hull with ultramarine, then while this is wet, drop in a dark mix of ultramarine and burnt umber on the underside. Allow to dry.

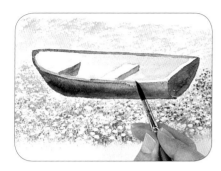

6 Paint the stern, the dark under the seats and the gunwhale with burnt umber and allow to dry.

7 Paint the shadow of the boat on the shingle with shadow colour, making it darkest closest to the boat.

8 Dot a dark mix of ultramarine and burnt umber in the shingle in front of the boat.

9 Paint the tops of the seats and the gunwhale at the stern with a pale mix of raw sienna.

The finished painting.

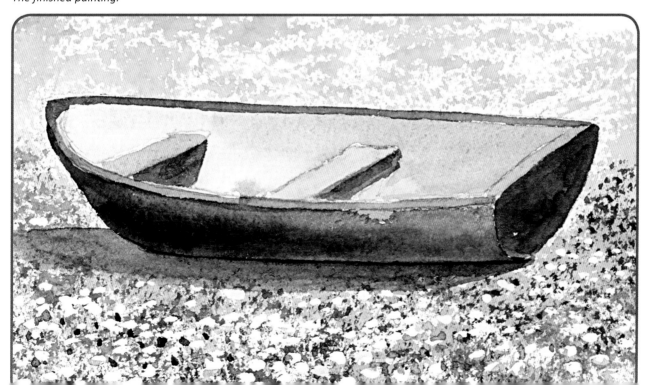

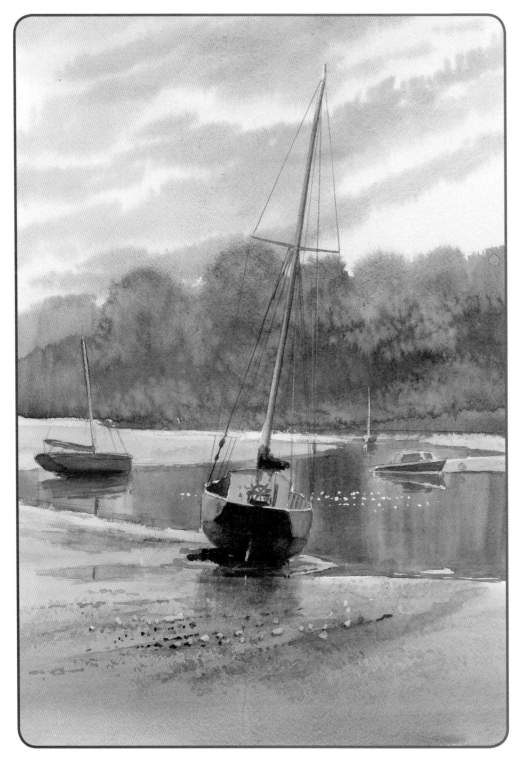

Stranded

Boats moored in a tidal estuary are just as interesting to paint as boats in full sail; the advantage is that they stay still. Masking fluid was used on the masts, the sparkling light on the water and the stones in the foreground. The colours of the central boat are reflected on the wet mud.

Opposite

Low Tide

The easy option when painting boats is to view them from dry land, but there is sometimes a better way. There are times when you must suffer for your art and get your boots wet, painting the boats from the mud flats further out, looking inland to the shore. The trees in the background can be an interesting contrast to the formal rigging and masts of the moored boats. The reflections in the foreground tell the viewer the shoreline is wet and muddy.

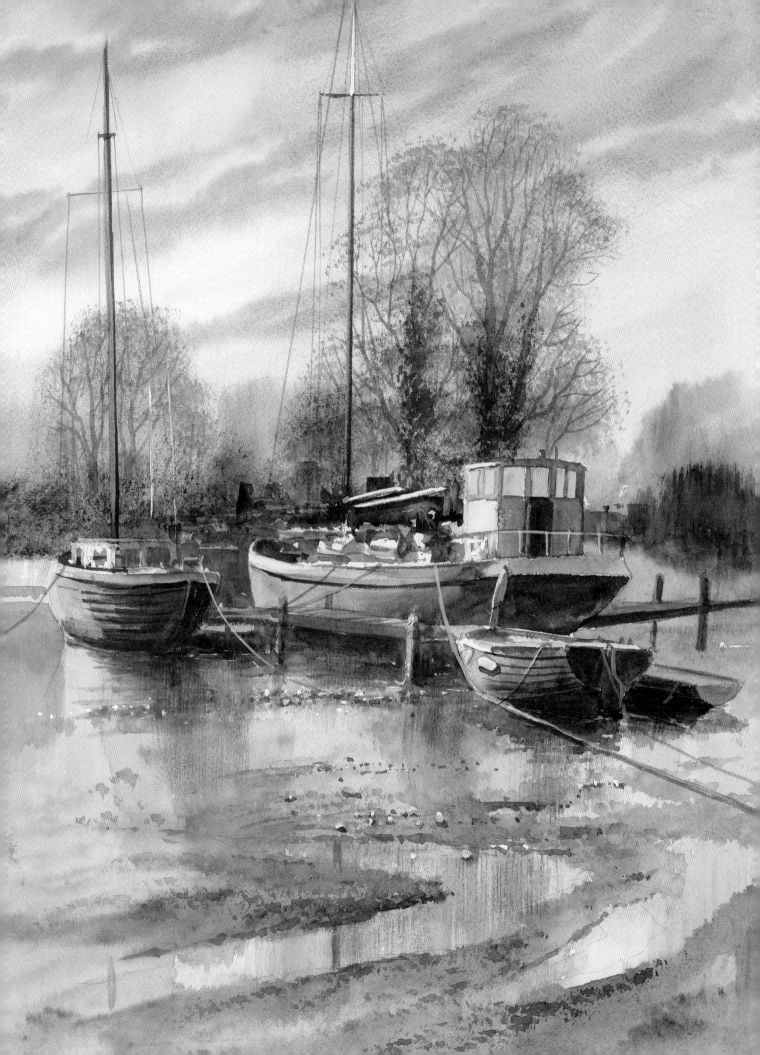

Adding life

Boats and people often go together, and at any time in a harbour there is always something going on. Messing about in boats is a major occupation for some people, and for some it's an obsession. You don't have to look far to find someone doing interesting things along the waterfront: sailors preparing to sail, craftsmen repairing crafts and the catch of the day being caught – even a survivor with his own paddle! Every scene tells a story.

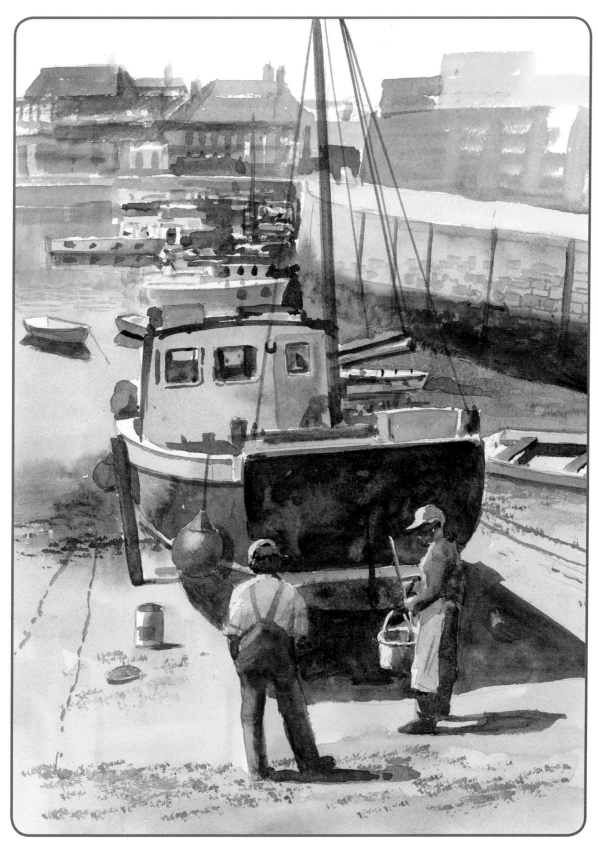

Expert Advice

Boats are high maintenance; there is always something to be done and always someone to offer advice. The workman and his expert supervisor are the main subjects in the foreground; the distant boats and buildings are less important and are painted quite loosely without much detail.

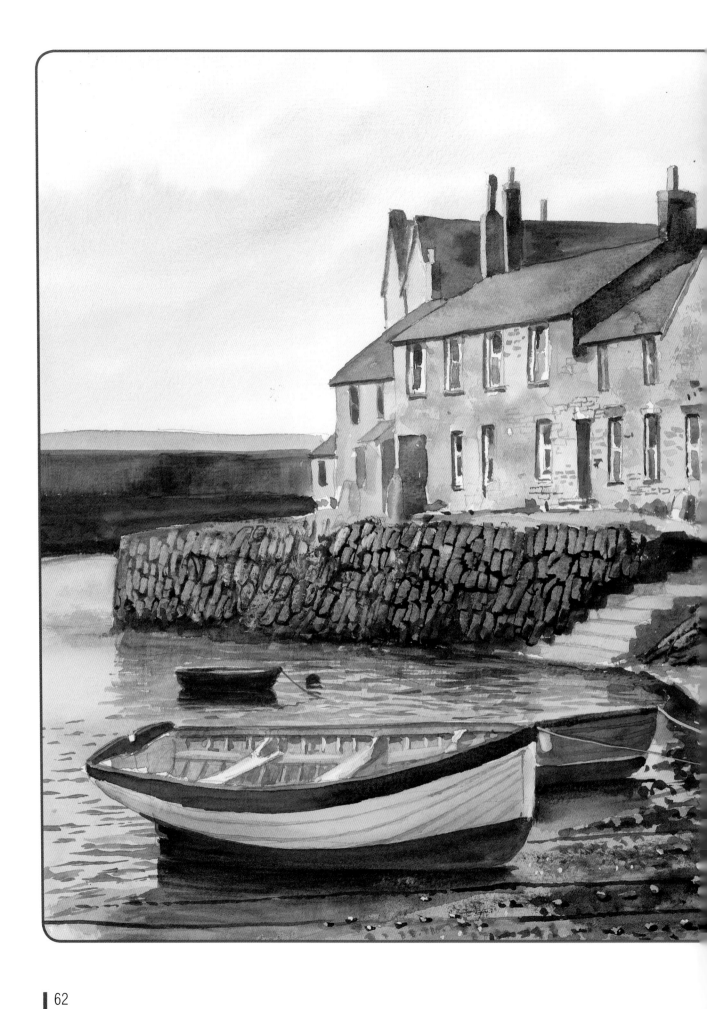

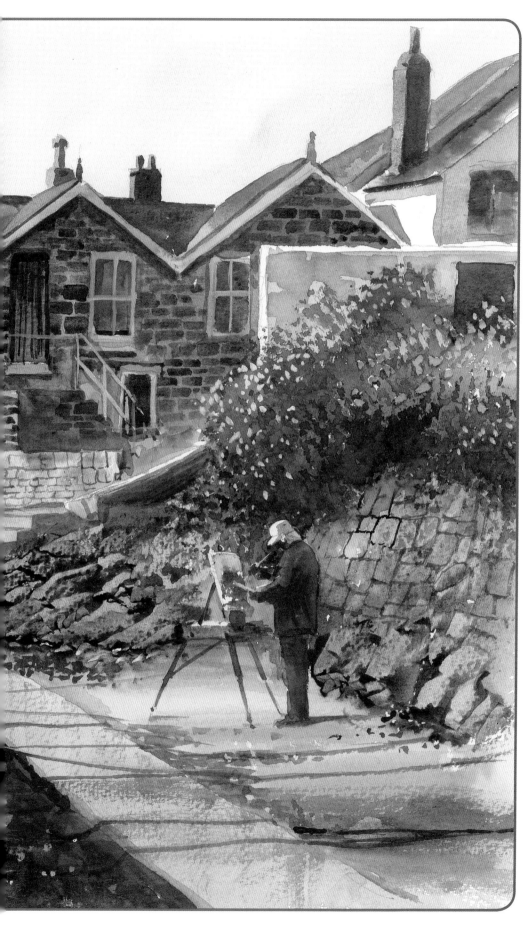

Artist's Paradise

Placing the artist in the middle distance adds special interest to this picturesque setting without dominating the scene. The painting is still all about the harbour, but with a twist.

Moods of the sea

Calm sea

Keep your brush strokes simple when painting a calm sea: short horizontal brush movements are all you need to succeed. The ripples are smaller and shorter in the distance, but become bolder and larger in the foreground, creating a sense of distance.

You will need
..
Colours: ultramarine blue, midnight green

Brushes: golden leaf, 19mm (¾in) flat

1 Wet the area with the golden leaf brush and clean water. Use the 19mm (¾in) flat brush to paint a wash of ultramarine from the bottom upwards, with horizontal strokes. It should become paler towards the top as the water on the paper dilutes the blue.

2 Wash the brush and squeeze it out to create a 'thirsty' brush, then use the flat edge to lift out ripples with little horizontal strokes.

3 Mix ultramarine and midnight green and touch in darker ripples. Make them smaller further away and larger and darker coming forwards.

The finished calm sea.

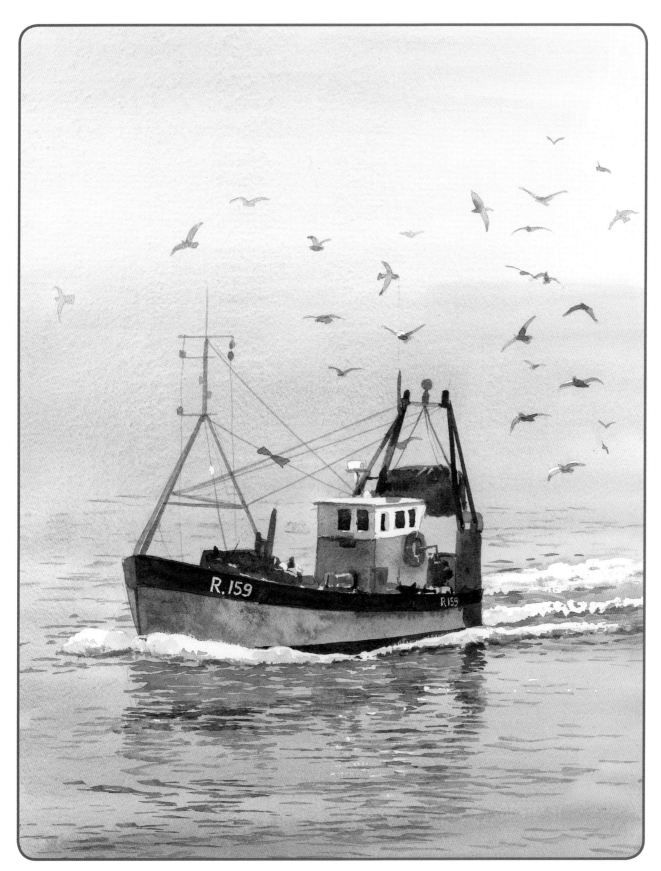

Fishing Boat Frenzy
All the action is in the air as the gulls follow the boat on its way home. The stillness and calm of the sea, with the minimum or ripples, is a nice contrast to the excitement above.

Choppy sea

Lifting out ripples using a thirsty brush only works when the brush has less liquid in it than the paint you are lifting. Choppy waves are achieved through a series of short, shallow curved brush strokes, swinging from one side to the other.

You will need

Colours: ultramarine blue, midnight green

Brushes: golden leaf, 19mm (¾in) flat

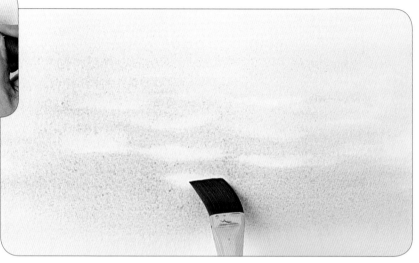

1 Wet the paper with the golden leaf brush and clean water, and paint on ultramarine with a little midnight green, in horizontal strokes, upwards towards the horizon. Wet then squeeze dry the 19mm (¾in) flat brush so that it is 'thirsty', then lift out thick curves to suggest choppy water.

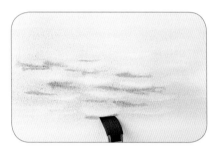

2 While the wash is still wet, pick up a strong mix of ultramarine and midnight green and paint marks suggesting shadow under the lifted-out waves. Allow to dry.

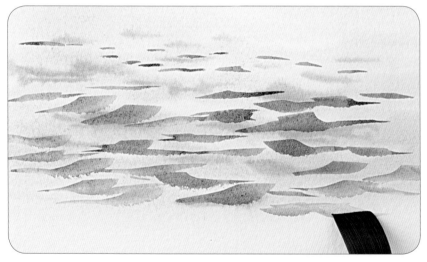

3 Continue painting thick curves on the dried background, making crisper shapes to create waves.

The finished choppy sea.

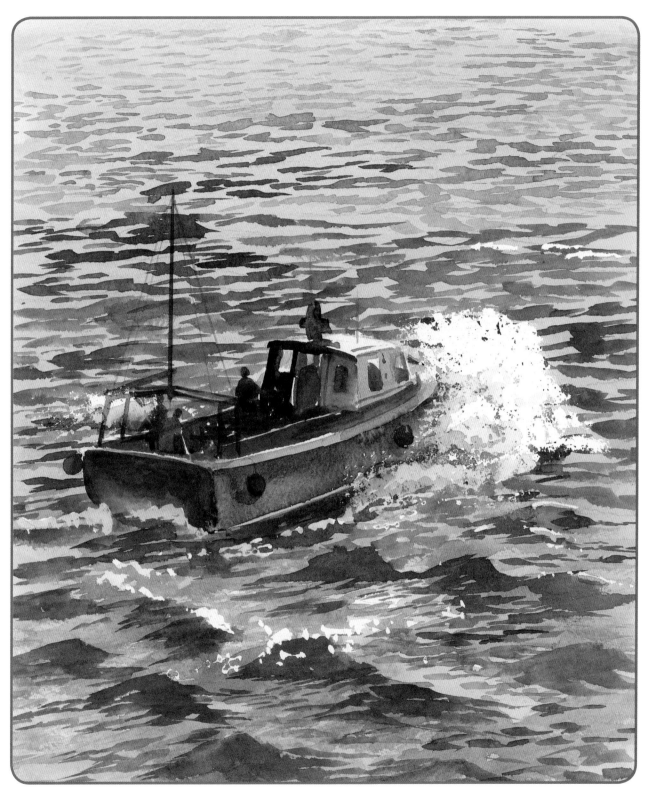

The Fishing Trip

The wind is picking up, the water is getting choppy and the boat is rising and falling in the swell, creating spray over the bow. The spray is masked using masking fluid applied with kitchen paper. The distant waves are smaller than the foreground waves, creating the feeling of depth in the painting.

Rough sea

Using masking fluid is perfect for capturing the crashing spray and the white wave crests in a stormy sea. Plenty of dark colours are needed to contrast with the white of the foam. A deep blue-green can be mixed using ultramarine and midnight green.

You will need

Colours: ultramarine blue, midnight green

Brushes: large detail

Masking fluid and masking fluid brush

Kitchen paper

1 Draw in some waves. Pour masking fluid on to a plate, scrunch up some kitchen paper, dip it in and dab it on some of the wave crests to create foam and spray. Continue masking the wave crests with a masking fluid brush. Allow to dry.

2 Use the large detail brush and a wash of ultramarine blue to paint waves over the masking fluid.

3 Paint wave shapes and shadow under the masked-out crests with a darker mix of ultramarine and midnight green. Keep the colour darkest under the crests, then pull it out to fade it into the troughs of the waves. Allow to dry.

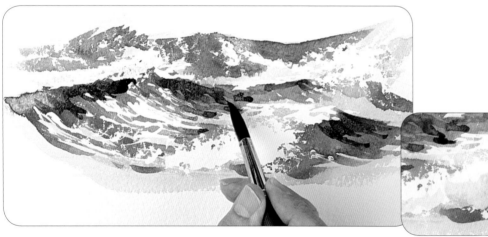

4 Remove the masking fluid with a clean finger. Use a darker mix of ultramarine and midnight green to paint a stronger shadow under the white and pull down lines into the wave troughs. Paint a pale mix of ultramarine into the foam to suggest texture and shade.

The finished rough sea.

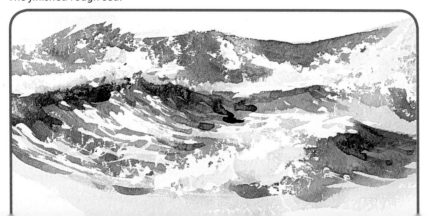

Opposite

Full Sail

A stormy day out at sea with a tall ship in full sail is a magnificent sight. To capture the drama, the sky was painted in dark tones using burnt umber and ultramarine. This makes the light sails stand out against the storm clouds. The sails were masked using masking fluid to allow the clouds to be painted using sweeping brush strokes across the sky without fear of getting paint on the sails. When the sky was dry, the weathered sails were painted using raw sienna and shadow.

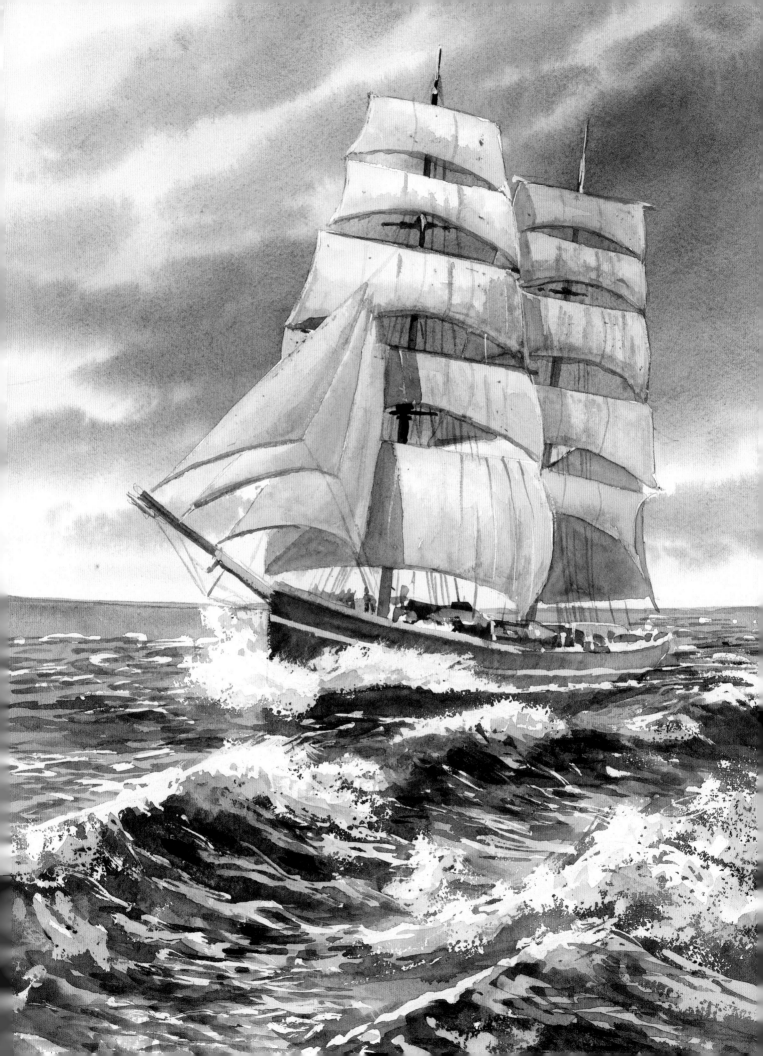

Sparkling water

The sparkle on sunlight on water is a magical sight and very easy to achieve in watercolour with the use of masking fluid. There is no short cut; you need to dot in each spot of light using an old brush.

You will need

Colours: ultramarine blue, midnight green
Brushes: 19mm (¾in) and 13mm (½in) flat
Masking fluid and old brush

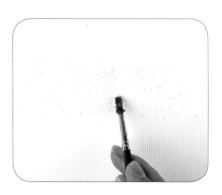

1 Dot masking fluid on to the sea area for sparkles, making them more concentrated in the middle. Allow to dry.

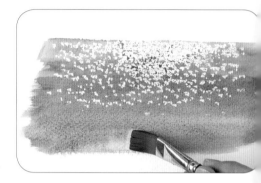

2 Mix ultramarine blue and midnight green and use the 19mm (¾in) flat brush to stroke it across the sea, creating a straight horizon. Allow to dry.

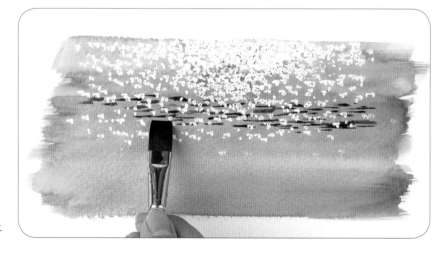

3 Use the 13mm (½in) flat brush and a darker mix of the same colours to paint on dark little ripples with the flat of the brush. Allow to dry, then remove the masking fluid with a clean finger.

The finished sparkling sea.

Opposite

Harbour at Sunset

The shape of the sun was lifted out using a coin tightly wrapped in kitchen paper and placed on the still-wet sky. The sunlight on the water and the tops of the boats was masked with masking fluid. The dark ripples were painted using the 13mm (½in) flat brush.

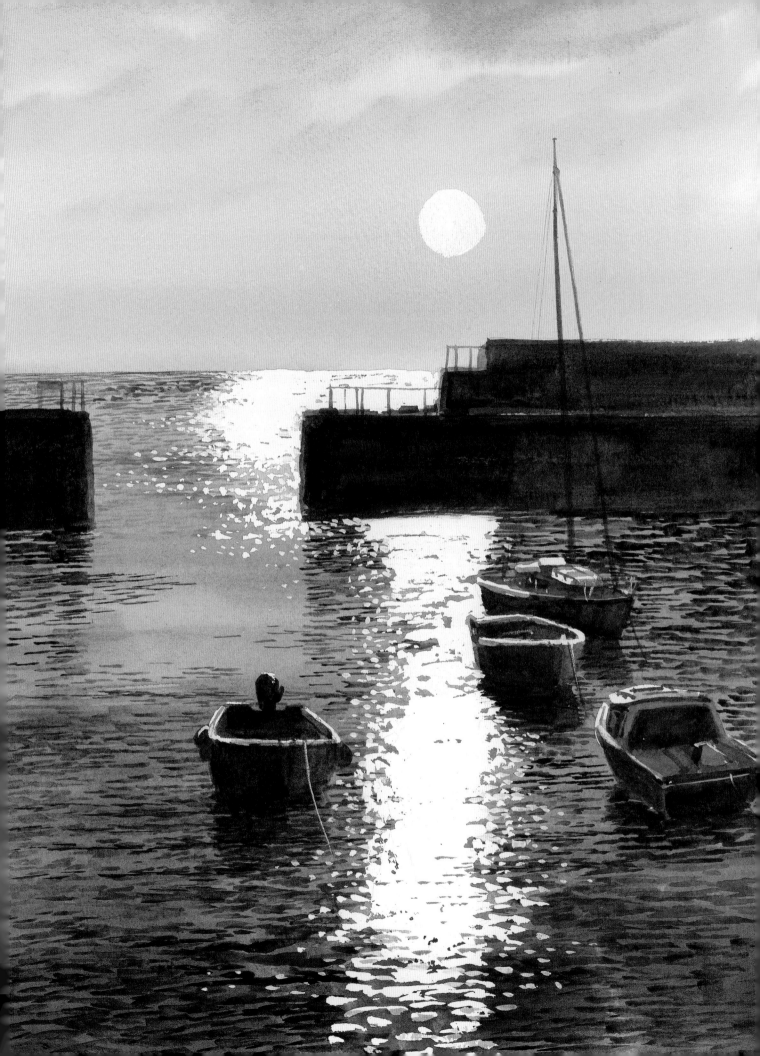

Messing about in boats

A sailing boat at sea

Care must be taken when drawing and painting sails. Don't be afraid of using a straight edge such as a ruler or a flexible curve to help you draw a clean line. Sailing boats with tall masts are often painted in portrait format. Cropping the sail and changing the shape to a landscape format can make for a more dramatic painting.

You will need

Colours: ultramarine blue, burnt umber, midnight green, raw sienna, cobalt blue, burnt sienna

Brushes: large detail, medium detail, small detail

Flexible curve

Masking fluid and old brush

Ruler

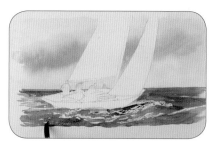

1 Draw the boat, using a flexible curve to help you with the sail if you have one. Dot masking fluid on the waterline and on sparkles on the waves.

2 Use the large detail brush to wet the sky area, leaving the sails dry. Paint the sky with ultramarine blue, leaving spaces for white clouds. While this is wet, drop in a dark cloud mix of burnt umber and ultramarine. Allow to dry.

3 Draw the horizon with a mix of ultramarine and midnight green and continue downwards to paint the sea in broken, rippled lines, going around the boat. Add more midnight green coming forwards.

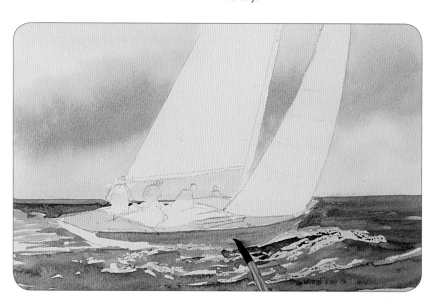

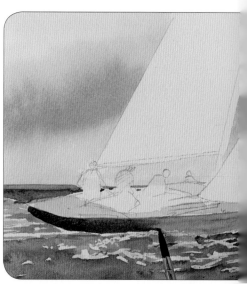

4 Paint the inside of the boat with the medium detail brush and raw sienna. Allow to dry, then paint the hull with cobalt blue and raw sienna.

5 Mix ultramarine and burnt umber and paint the darker part of the stern.

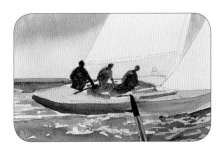

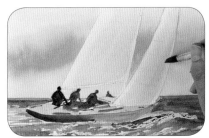

6 Paint the silhouettes of the figures in the boat with a dark mix of burnt sienna and ultramarine.

7 Wet the sails with clean water, then sweep in touches of pale raw sienna to lose the stark whiteness. Add cobalt blue for the shaded sides, working wet into wet. Allow to dry.

8 Use the edge of a ruler with the small detail brush and a mix of burnt sienna and ultramarine to paint the mast and boom of the main sail. Allow to dry.

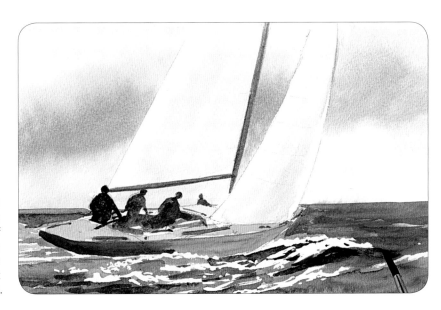

9 Remove the masking fluid with a clean finger. Use the medium detail brush and a mix of ultramarine and midnight green to refine the shading under some of the white wave crests, and paint some darker ripples.

The finished painting.

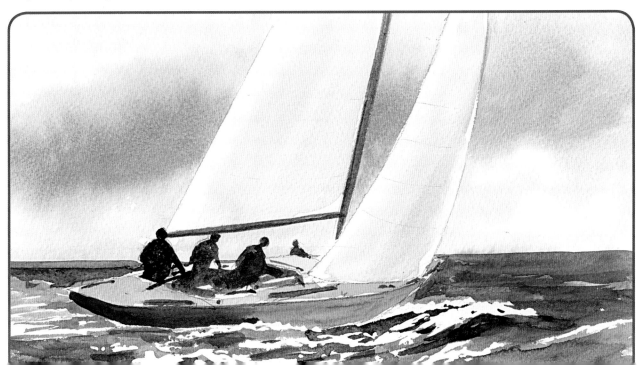

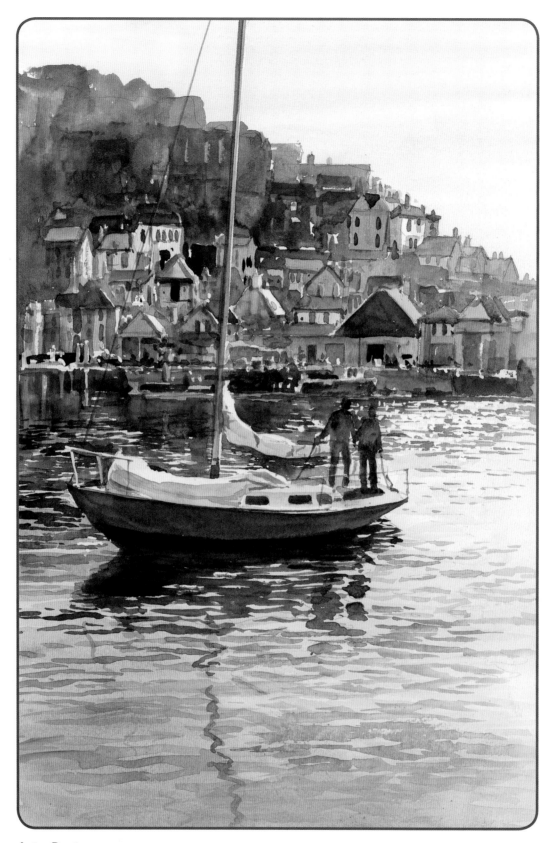

Into Port

Safely home into port after a fun day's sailing. The late evening light is reflected in the water and just catches some of the quayside buildings. A wash of raw sienna in the sky and water helps to create a warm glow, and together with the darks of the headland and harbour, this gives the impression of light within the painting.

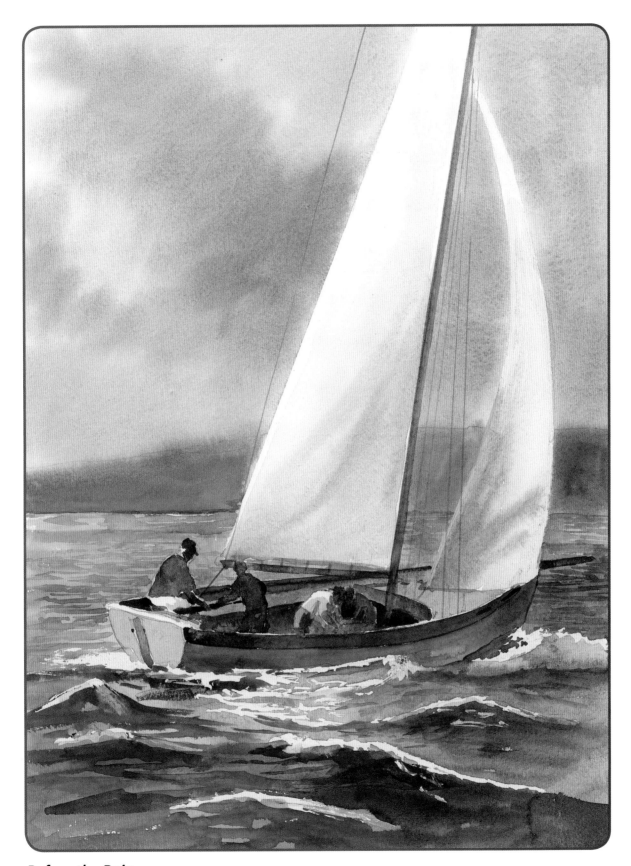

Before the Rain

The dark of the sky helps to make the sails really stand out, and this also adds a hint of drama. You can just imagine the rush to get to port ahead of the squall. Masking fluid was used on the sails and the reflections in the water.

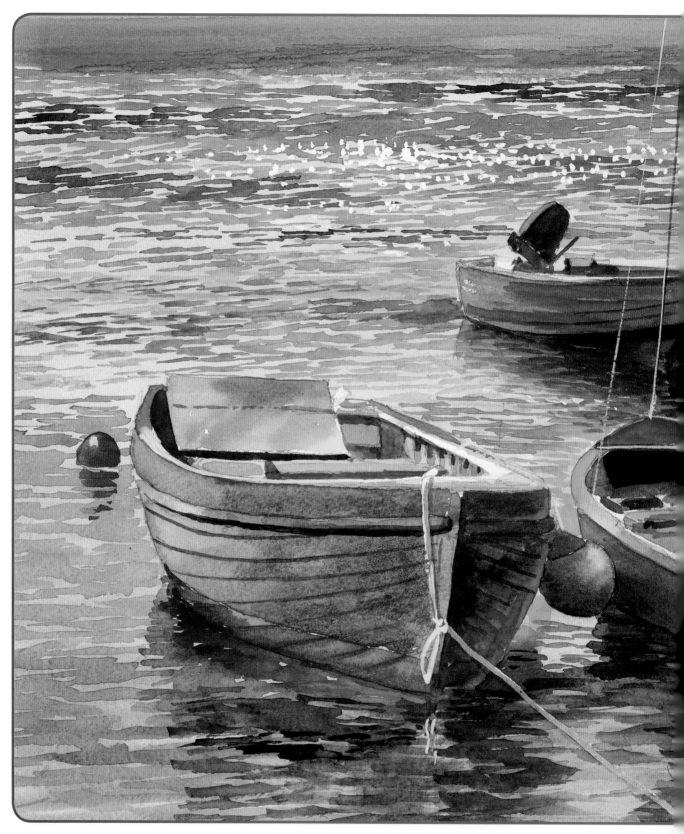

Sea Breeze

What a fine sight – boats of all shapes and sizes bobbing about in the safety of the harbour. A light sea breeze just catches the water and ripples the reflections, to suggest the gentle movement of the boats. The sun sparkling on the water was made possible by using masking fluid. The finishing touch of the rigging is painted using the half-rigger brush, a ruler and white gouache.

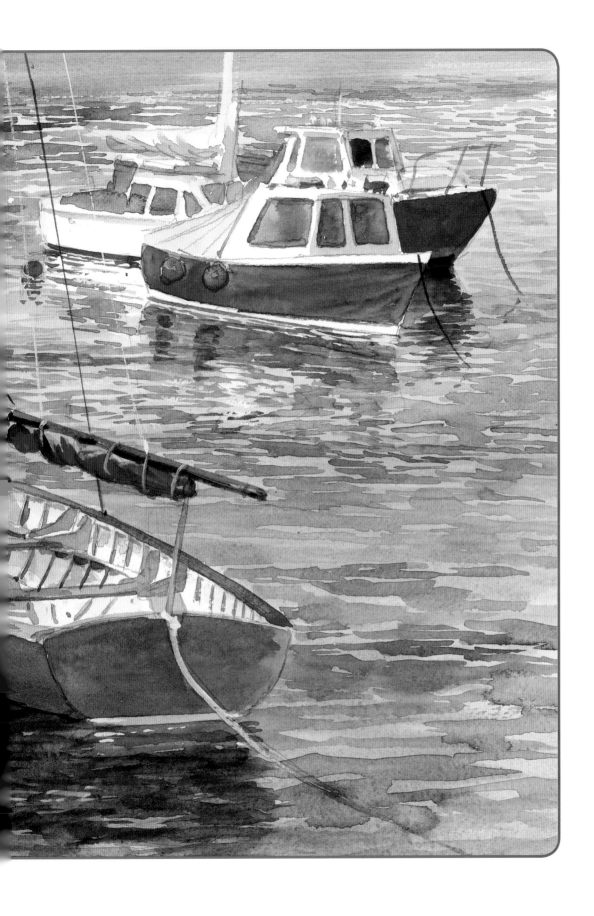

Day Trippers

This is a busy holiday harbour. The little pleasure boats are patiently waiting for the tide to return so they can take the day trippers out for a taste of the high seas. Cobalt blue was used for the sky and the clouds were lifted out using kitchen paper. Adding people and cars to the painting makes the whole place look busy, with the holiday season in full swing. Some of the stonework on the harbour wall is outlined using dark paint, whereas other stones have cement in their joints, and this is painted using white gouache.

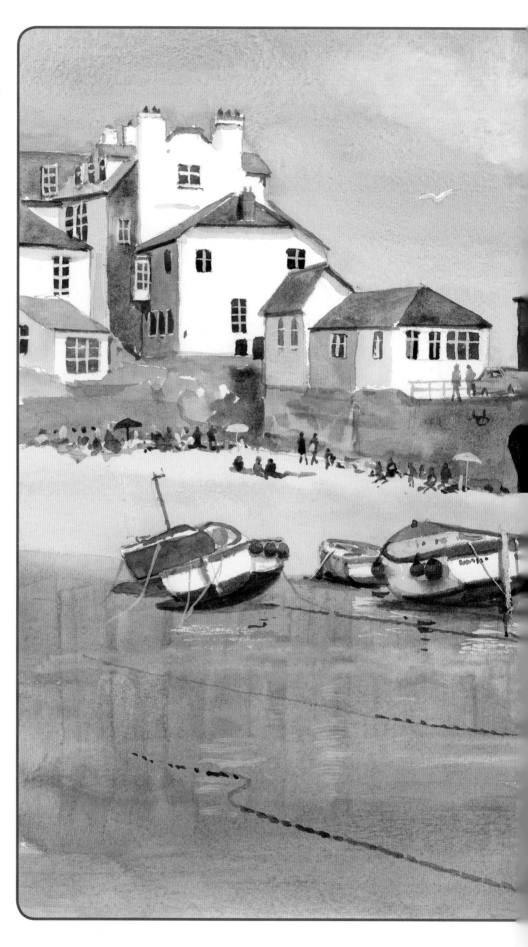

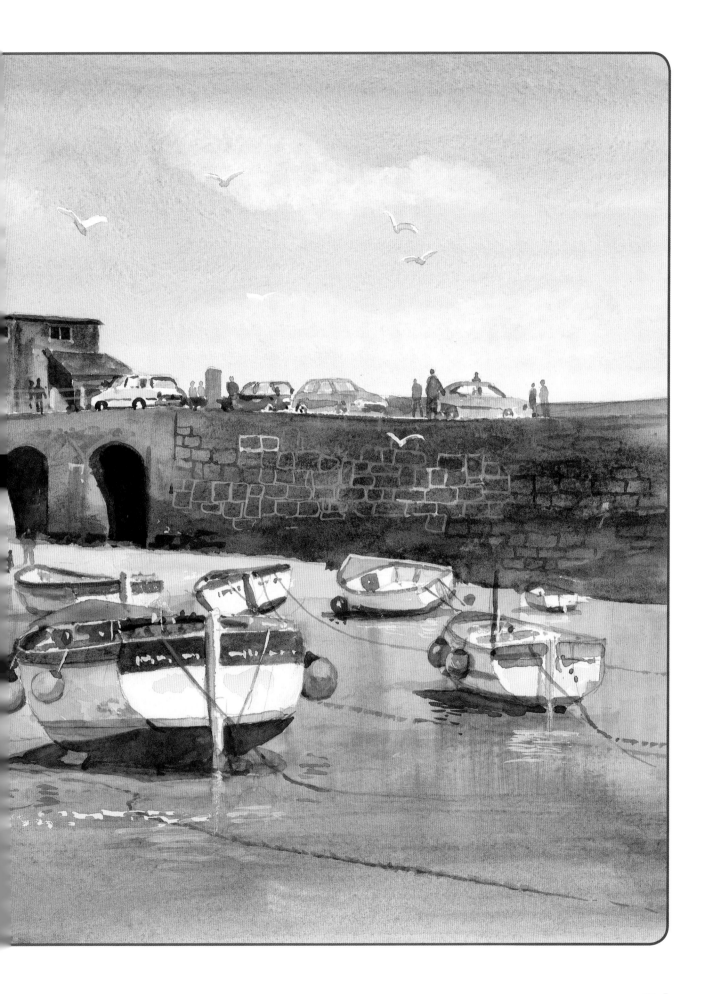

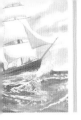

Ship at Sea

Being an island nation, the British have always had a fascination with all things nautical. Painting tall ships in full sail can be quite challenging, as this is not the type of thing you see every day of the week. You don't have to be a naval expert, however; just paint what you see or, in this case, follow the instructions.

You will need

Colours: raw sienna, ultramarine blue, burnt umber, midnight green, cobalt blue

Brushes: golden leaf, large detail, small detail, half-rigger

Masking fluid and old brush

Kitchen paper

Ruler

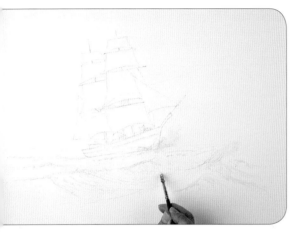

1 Draw the ship. Apply masking fluid on scrunched-up kitchen paper to create the spray, especially round the ship, then with a brush for the white wave crests. Allow to dry.

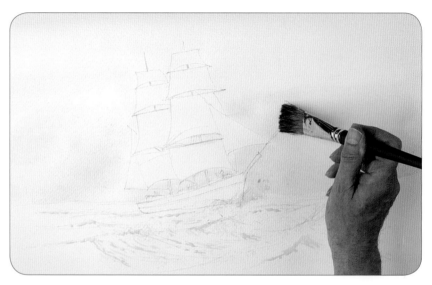

2 Wet the sky, leaving the sails dry, using the golden leaf brush and the large detail brush to work round the sails. Drop in raw sienna in the lower part of the sky using the golden leaf brush.

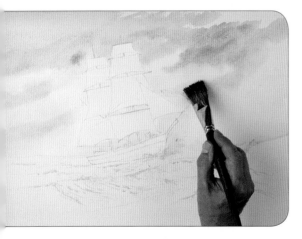

3 Brush in cloudy shapes using ultramarine blue, working wet into wet.

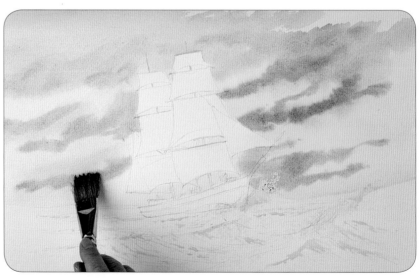

4 While the paint is still wet, brush in a mix of ultramarine and burnt umber for darker cloud, creating drama by putting them in at an angle.

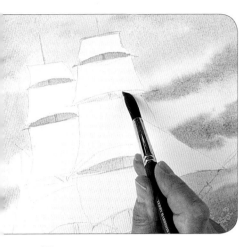 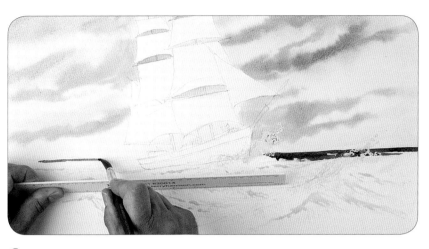

5 Use the large detail brush to paint between the ship's sails with the same mix. Allow to dry.

6 Paint the horizon with a dark mix of ultramarine and midnight green, using a ruler to help you keep the line straight and horizontal.

7 Paint the trough of the wave beneath the ship with ultramarine and a touch of midnight green. Continue painting the sea, using directional strokes to suggest the movement of the waves.

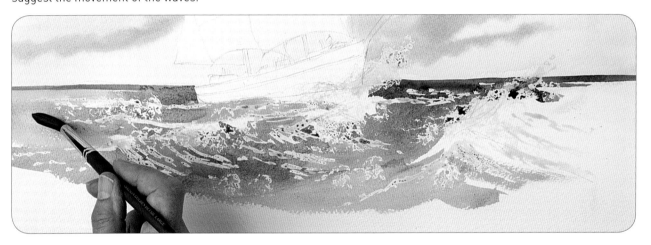

8 Use a very dark mix of ultramarine and midnight green to paint around the masked-out wave crests in front of the ship, then create peaked shapes for the waves, making them larger in the foreground.

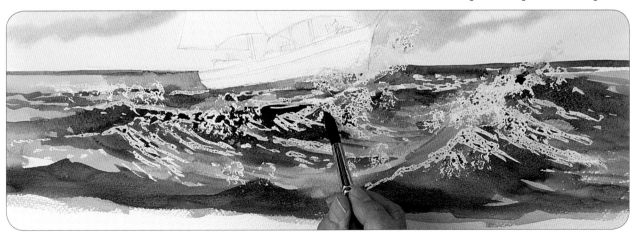

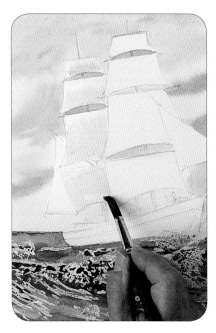

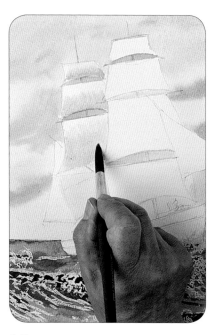

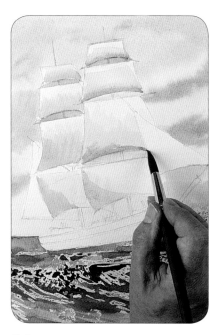

9 Wet the left-hand sails with clean water, then drop in raw sienna.

10 Drop in the shadow wet into wet, using vertical strokes of the brush with a pale wash of cobalt blue. Allow to dry.

11 Wet the right-hand sails and repeat the same process, dropping in raw sienna, then cobalt blue. Mix cobalt blue with raw sienna to paint a deeper shade along the bottom of each sail. Allow to dry.

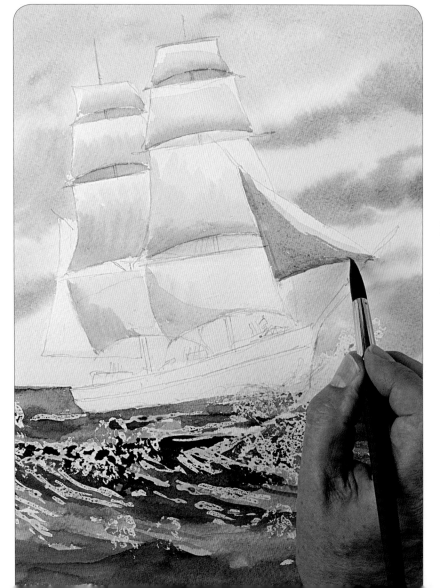

12 Paint the triangular sail on the right without pre-wetting the paper. Paint a hard diagonal line with raw sienna, just leaving the top right-hand edge of the triangle white. Paint the darker cobalt blue and raw sienna shade over this.

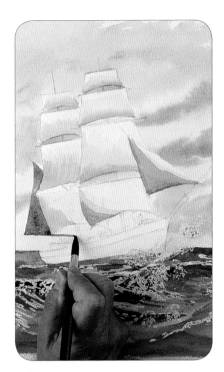

13 Add shadow to some of the other sails in the same way. Mix cobalt blue and burnt sienna to make a darker mix and shade the sail in the background.

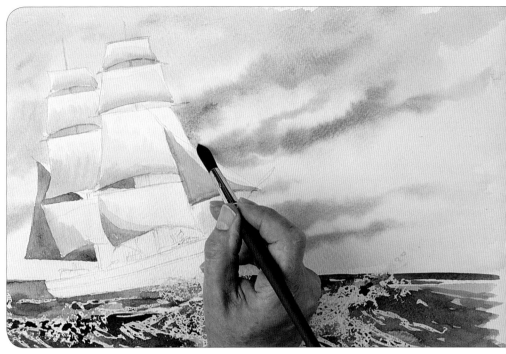

14 It is always important to step back from your painting from time to time to assess how it is working. At this point, I decided that I needed to darken the sky behind the ship. If you need to do this, first wet the sky with clean water, wetting a larger area than you need to avoid creating hard edges. Then drop in ultramarine and burnt umber to create darker cloud, going up to the edges of the sails.

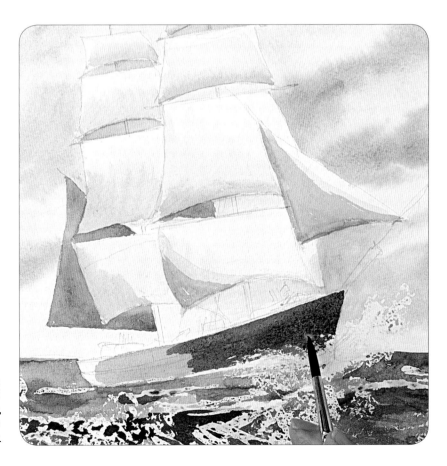

15 Paint the hull with the medium detail brush and a light mix of ultramarine with a little burnt umber, then add a darker mix of the same colours towards the prow.

16 Clean the brush and then squeeze out the excess water so that it is just damp, or thirsty, and use it to lift out a light area, suggesting the shape of the hull. Allow to dry.

17 Use the small detail brush and a dark grey mix of ultramarine and burnt umber to suggest detail and clutter on the deck of the ship.

18 Add a dark line across the hull in the same way.

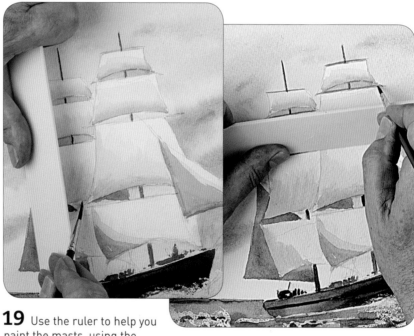

19 Use the ruler to help you paint the masts, using the half-rigger and the same dark mix of ultramarine and burnt umber. Paint the horizontal bars from which the sails hang in the same way.

20 Continue painting the rigging, using the ruler to help where necessary. Allow to dry.

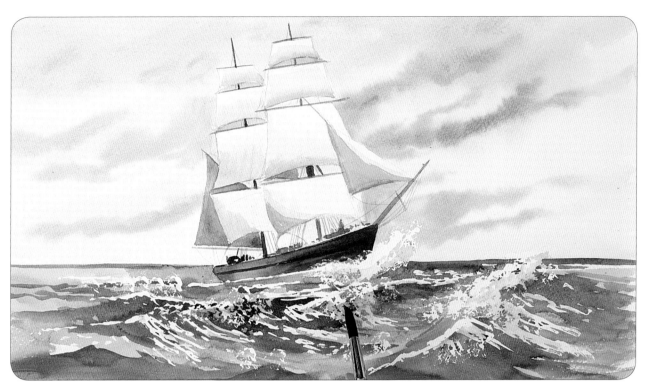

21 Remove the masking fluid with clean fingers. Use the large detail brush and a wash of cobalt blue to add a bit of shade and texture to the foam bursts and wave crests.

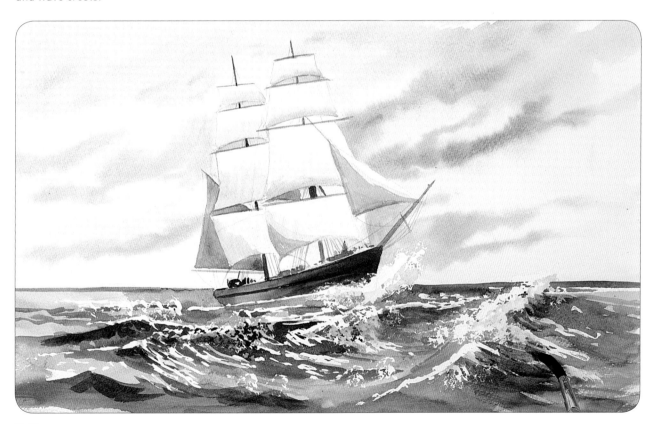

22 Make a dark mix of ultramarine and midnight green and paint dark sea detail under the wave crests and down into the troughs, to add form to the stormy water.

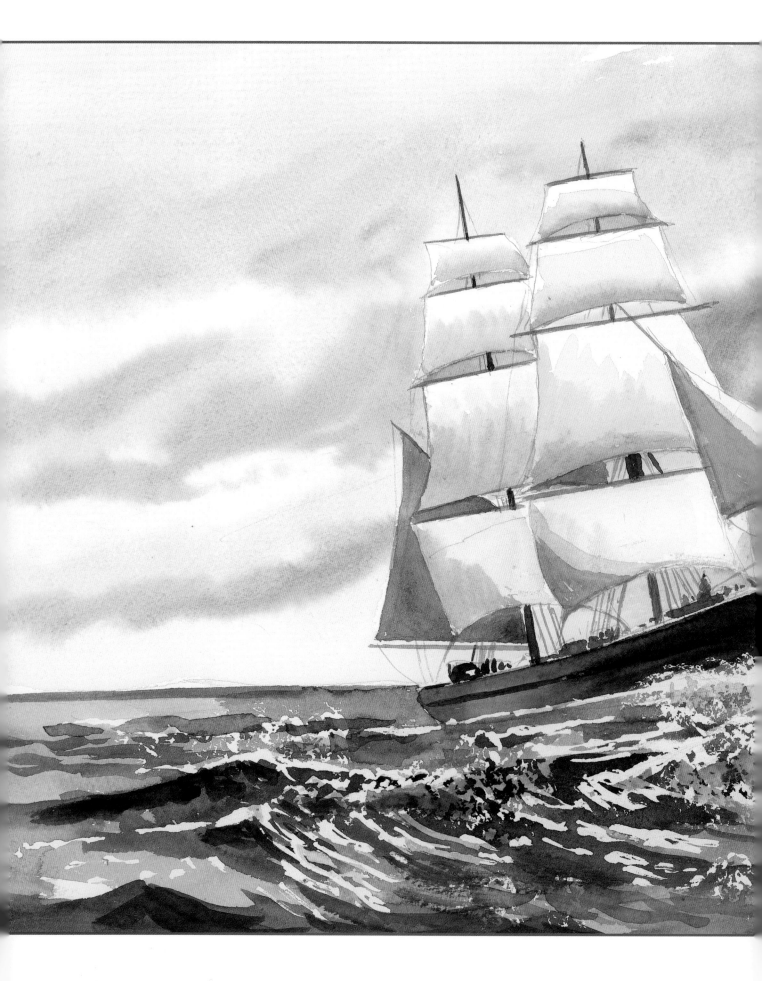

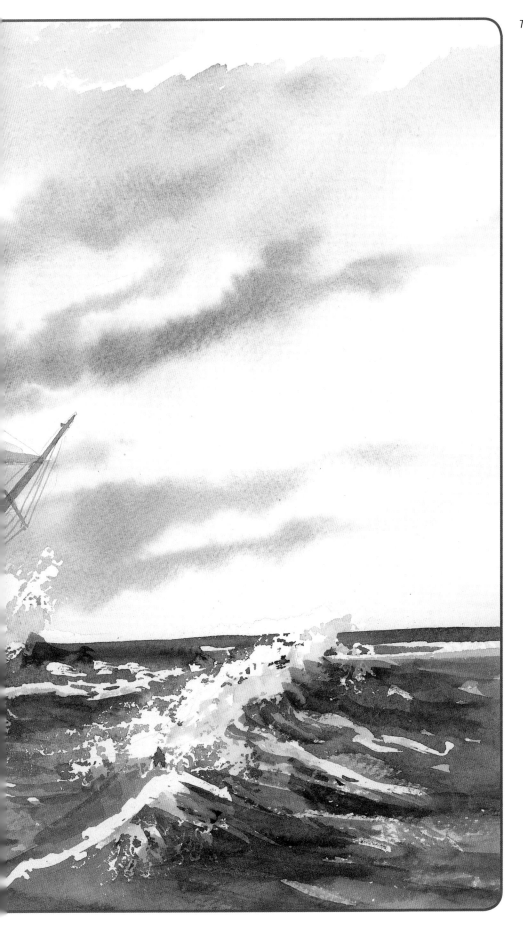

The finished painting.

Greek Boats

The closest most of us get to boats is on holiday. A romantic cruise down the coast, a swim in a sandy bay, lunch in a taverna, what more could you want? Well what about a memento of your trip? Many paintings are a reminder of a great holiday experience, and this project reminds me of many a trip. Calm water and simple reflections make this an easy subject to paint.

The old jetty leads you into the painting and the headland at the top helps to frame the boat and form a backdrop for the sun canopy.

You will need

Colours: cobalt blue, shadow, burnt sienna, raw sienna, midnight green, phthalo turquoise, ultramarine blue, burnt umber, cadmium red, cadmium yellow, shadow

Brushes: golden leaf, large detail, 19mm (¾in) flat, medium detail, small detail, half-rigger

Masking fluid and old brush

1 Draw the scene and mask the areas shown: the boat rails, ladder, fenders, ropes, the posts and light parts of the jetty and the rippled reflections of the lightest parts of the boat.

2 Wet the sky, down to the mountains, with the golden leaf brush and clean water. Paint cobalt blue from the top in horizontal strokes.

3 Use the large detail brush and a mix of shadow with a touch of burnt sienna to paint the distant hill. Mix shadow and raw sienna and paint the nearer hill with brush strokes following the contours of the land. Paint round the boat awning but over the masking fluid.

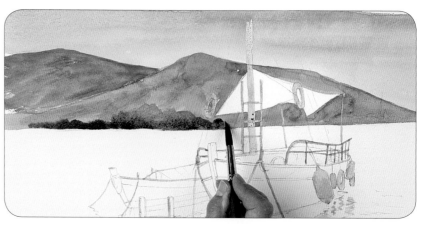

4 Mix shadow and midnight green and while the hillside is still wet, put in a suggestion of the trees along the water's edge.

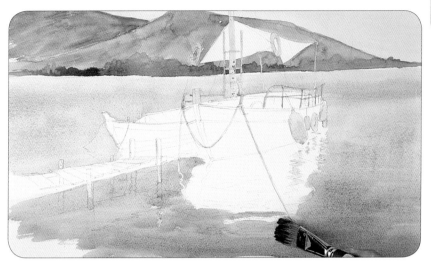
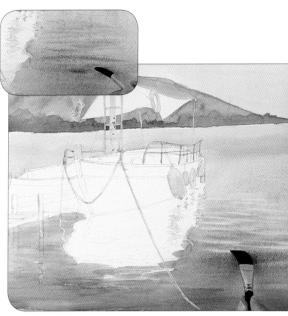

5 Use the golden leaf brush to wet the water area, going round the boat and reflections. Paint the area with a mix of cobalt blue and a touch of phthalo turquoise. Move down the paper in horizontal bands. Towards the foreground, paint a stronger mix of ultramarine blue and a touch of midnight green.

6 While the painting is still wet, add stronger ripples mixed from ultramarine and phthalo turquoise across the foreground. Wet and squeeze dry the 19mm (¾in) flat brush and use it to lift out ripples.

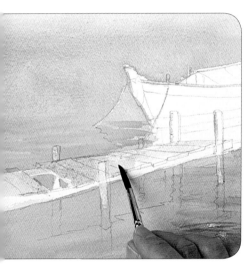
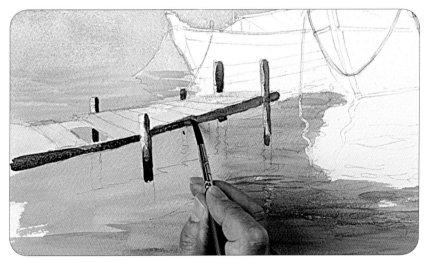

7 Paint the jetty with the medium detail brush and a pale mix of burnt umber, ultramarine and raw sienna.

8 Use a darker mix to paint the shaded sides of the posts and the edge of the jetty, going over the masking fluid.

9 Use the half-rigger and the same mix to paint the planking and the edge of the hole in the jetty. Change to the medium detail brush to paint the reflection of the jetty in the water, wet into wet.

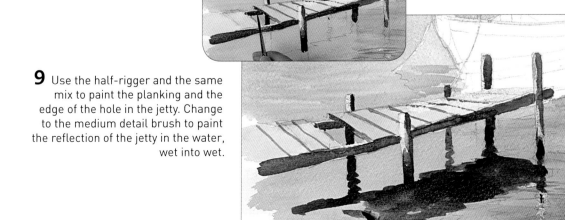

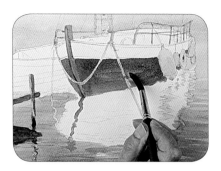 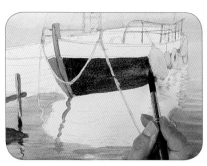 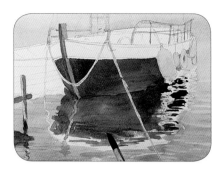

10 Use the small detail brush to paint the prow and its reflection with a strong mix of ultramarine, then the large detail brush to pain the hull.

11 While the hull is wet, drop in a darker mix of ultramarine and burnt umber for the shaded part.

12 Paint the reflection with a mix of ultramarine, burnt umber and midnight green, painting horizontal strokes for the rippled parts over the masking fluid, then blocking in the main area. Allow to dry.

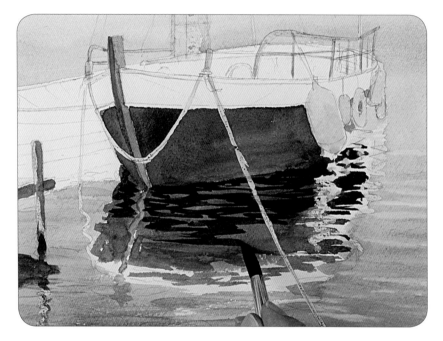

13 Make a darker mix of the same colours and paint dark ripples nearest the boat.

14 Paint the hull of the other boat with a mix of raw sienna and cobalt blue.

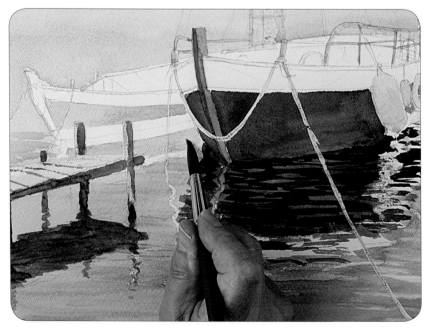

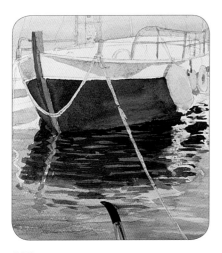

15 Paint a shadow on the white part of the main boat using the same mix, then use it again in parts of the reflection.

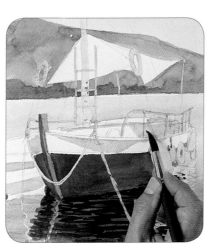

16 Continue using the same mix to paint the shadow cast by the boat's awning.

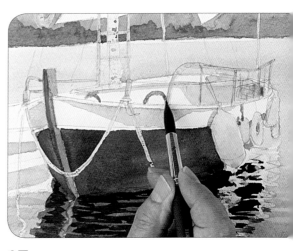

17 Paint some darker areas of shadow and the portholes with ultramarine.

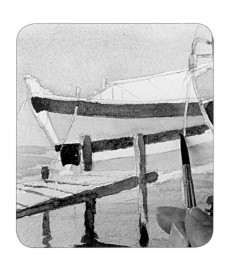

18 Use the medium detail brush with ultramarine and a touch of burnt umber to paint the dark stripes of the second boat.

19 Paint the reflection of the second boat with a wash of cobalt blue and raw sienna.

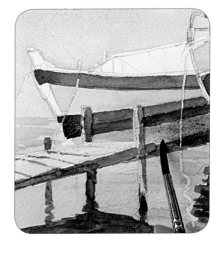

20 Use the small detail brush and cadmium red to paint the prow of the second boat and the gunwhale and rim of the main boat.

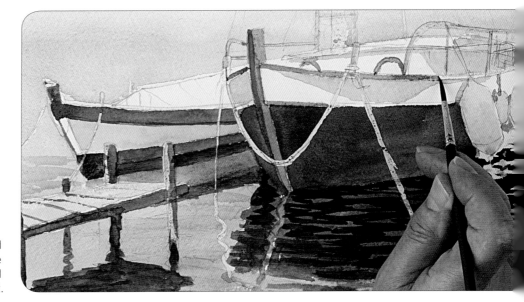

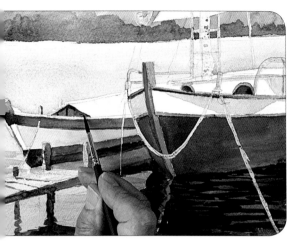

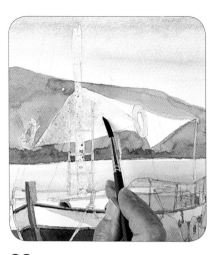

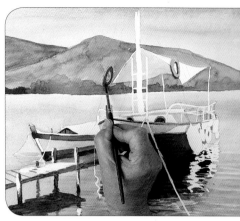

21 Paint the dark in the portholes in the main boat and the shadows under the awning of the second boat with ultramarine and burnt umber.

22 Shade the awning of the main boat with a mix of cobalt blue and burnt sienna, using the medium detail brush. Allow to dry.

23 Remove the masking fluid with a clean finger. Paint the lifebelts with cadmium red and cadmium yellow and allow to dry, then add shade with shadow colour.

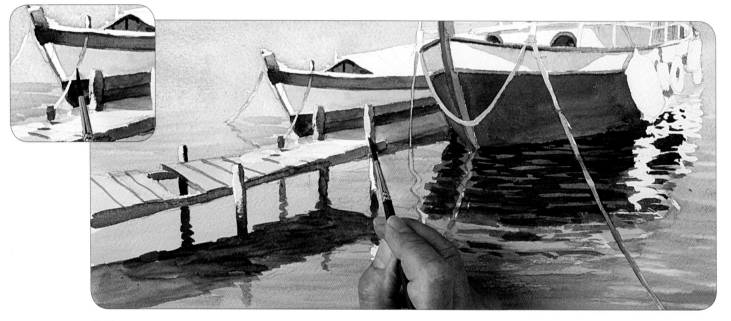

24 Use the small detail brush to paint very pale burnt umber on all the mooring lines, then paint the jetty with raw sienna on the highlighted parts that were masked.

25 Shade the ladder and the left-hand side of the mast with cobalt blue and raw sienna.

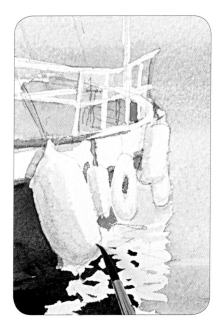 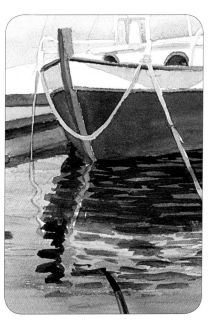 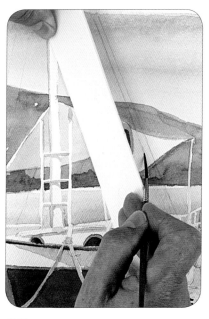

26 Paint shade on the fenders with a pale mix of cobalt blue.

27 Use the medium detail brush to paint the reflection of the prow with ultramarine, burnt umber and midnight green, and add ripples.

28 Paint the rigging with the half-rigger, with a mix of cobalt blue and a touch of raw sienna, using a ruler to help you.

29 Add some colour to the white reflections with a pale mix of cobalt blue and raw sienna on the small detail brush.

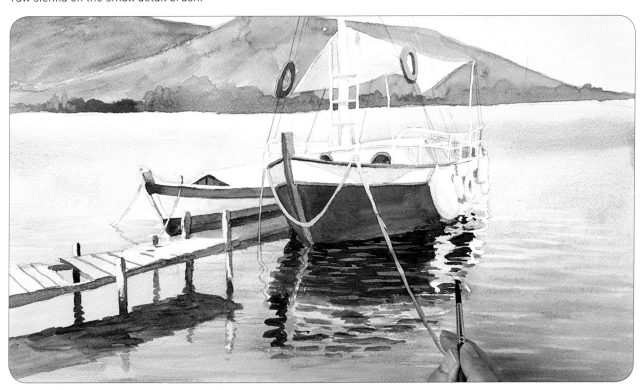

Overleaf
The finished painting.

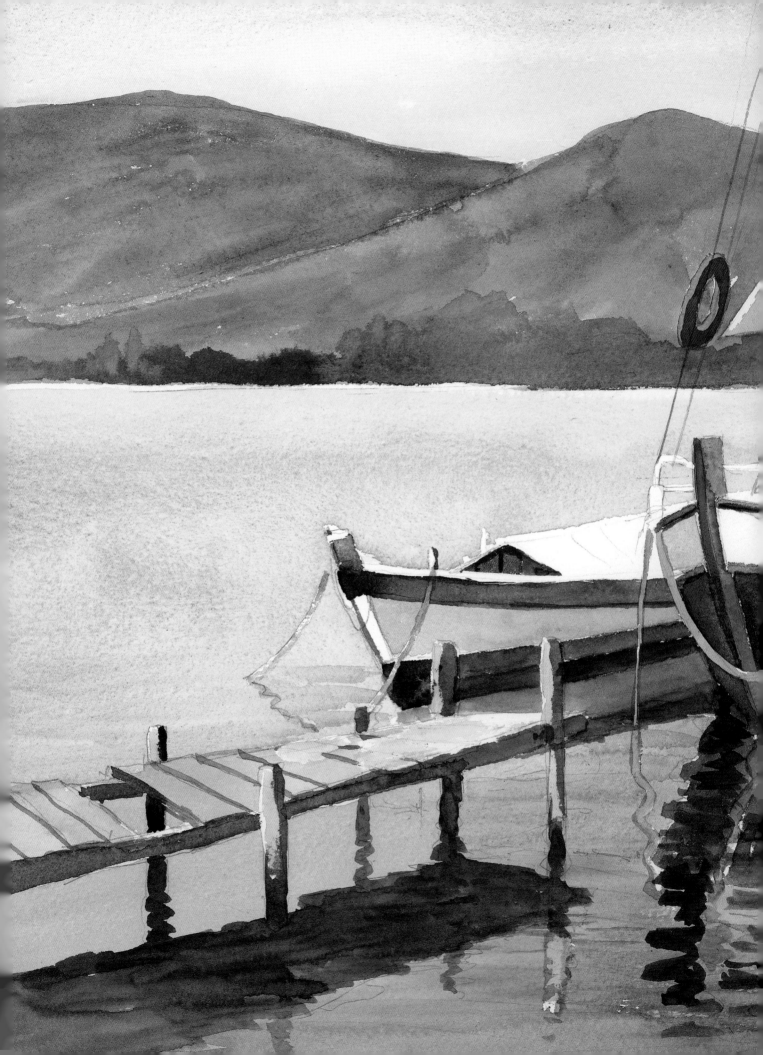

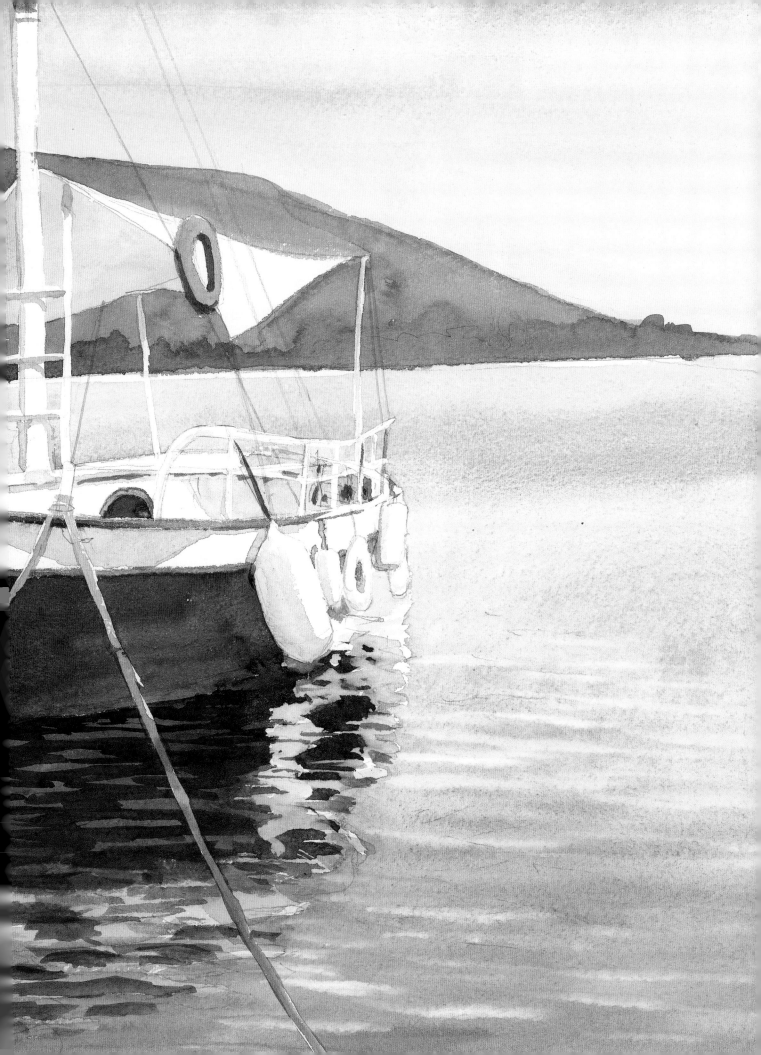

River Harbour

This project has everything: boats, a landscape with trees – even a pub! What more could an artist want? Often when painting boats, you paint from the land, looking out to sea. Looking back the other way sometimes offers more possibilities. The landmark of this mooring is the pub, so it makes sense to paint from beyond the boats, looking inland, but the only way to do this is at low tide. Only the mast on the Thames barges and some sparkles of light in the foreground were masked.

You will need

Colours: raw sienna, ultramarine blue, burnt sienna, burnt umber, shadow, cobalt blue, midnight green, alizarin crimson, country olive, cadmium red, cadmium yellow, white gouache

Brushes: golden leaf, 19mm (¾in) flat, summer foliage, small detail, half-rigger, medium detail, 13mm (½in) flat

Masking fluid and old brush

Ruler

Paper mask

1 Draw the scene, then use masking fluid with an old brush and a ruler to mask the boat masts.

2 Wet the sky area with the golden leaf brush and clean water, cutting round the buildings. Brush a pale wash of raw sienna into the lower sky, then while this is wet, brush in large, loose, cloudy shapes with ultramarine blue, making them smaller near the horizon.

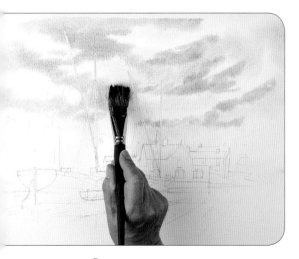

3 Brush in darker clouds with a mix of burnt umber and ultramarine, making them smaller near the horizon.

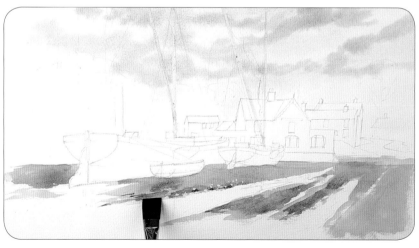

4 Paint the foreshore with the 19mm (¾in) flat brush and a mix of burnt sienna and shadow, leaving white space for puddles. Create texture with a slightly darker mix of the same colours.

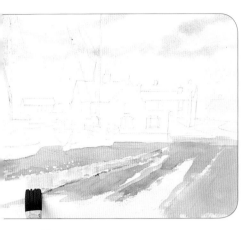

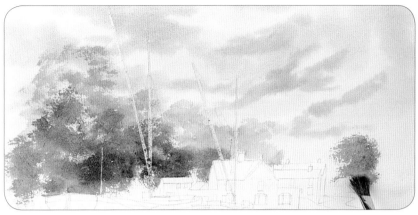

5 Mix cobalt blue and a touch of shadow, and stroke down reflections in the foreground pools of water.

6 Stipple on the background trees with the summer foliage brush and a mix of cobalt blue and shadow. Add burnt sienna to the mix lower down and use a paper mask to protect the buildings as you stipple the slightly nearer trees. Stipple some trees on the right of the scene in the same way.

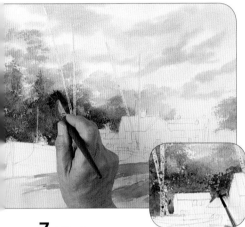

7 Stipple some darker winter foliage with a mix of midnight green and shadow. Add cobalt blue to the mix and use the small detail brush to tidy the edges of the buildings and darken behind them so that they stand out. Allow to dry.

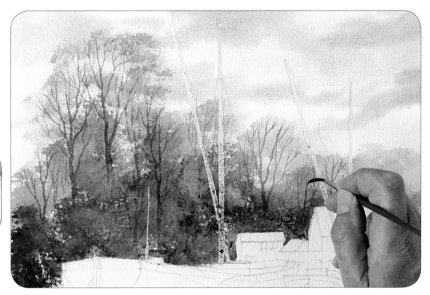

8 Use the half-rigger and a mix of burnt sienna and shadow to paint the tree trunks and branches over the dried background. Start from the bottom and paint upwards in the direction in which the trees grow.

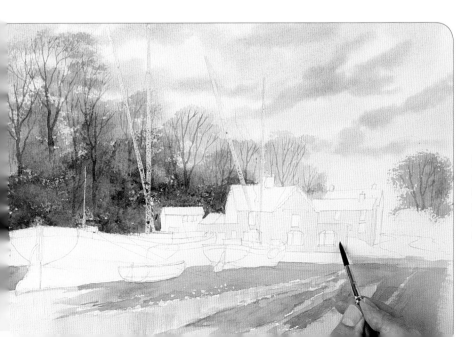

9 Paint one of the right-hand houses with the medium detail brush and a pale mix of alizarin crimson, going round the windows, then paint the main building with alizarin crimson and raw sienna in the same way.

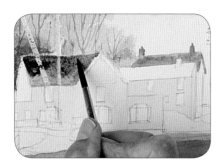

10 Paint the roof of the cottage at the back with burnt sienna, then drop in shadow. Continue, painting a non-adjacent roof in the same way.

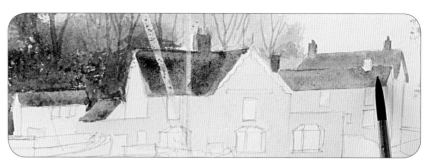

11 Continue painting the roofs in this way. Paint the slate roof with ultramarine and a little burnt umber.

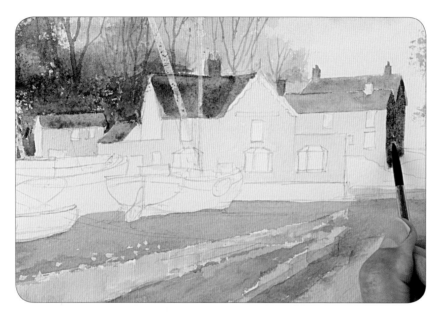

12 Paint the building on the left with pale raw sienna, then the shaded gable ends of the buildings on the right with shadow and burnt sienna.

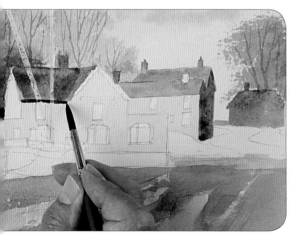

13 Use shadow and burnt sienna to paint a new building on the far right of the painting, then use a stronger mix to shade under the eaves of the main building.

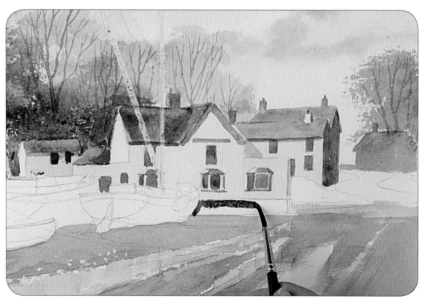

14 Make a dark mix of burnt umber and ultramarine and use the small detail brush to paint all the windows and the dark lower part of the main building.

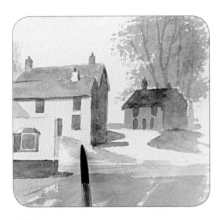

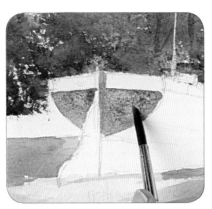

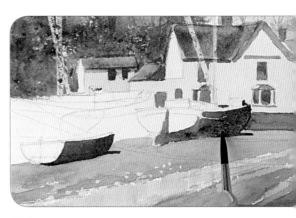

15 Use the medium detail brush and a mix of ultramarine and burnt umber to suggest detail on the house on the far right, and paint the edges of the road with the same mix.

16 Paint the stern of the boat on the left with burnt umber and ultramarine, then drop in raw sienna while this is wet.

17 Make a dark mix of ultramarine and burnt umber and paint the shaded parts of the two foreground boats, also indicating their cast shadows.

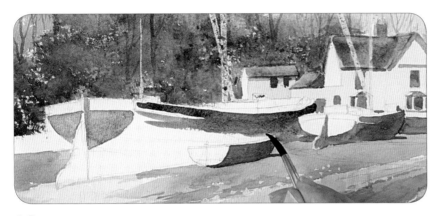

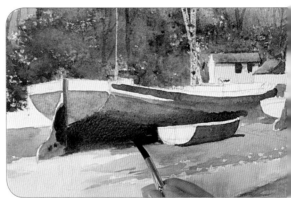

18 Once the stern of the boat on the left has dried, paint its hull with ultramarine and burnt umber, varying the shade to suggest the shape.

19 Mix country olive with burnt umber and ultramarine to shade the underside of the boat.

20 Suggest clutter on the decks of the two further boats with a dark mix of burnt umber and ultramarine.

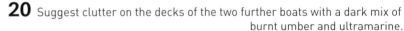

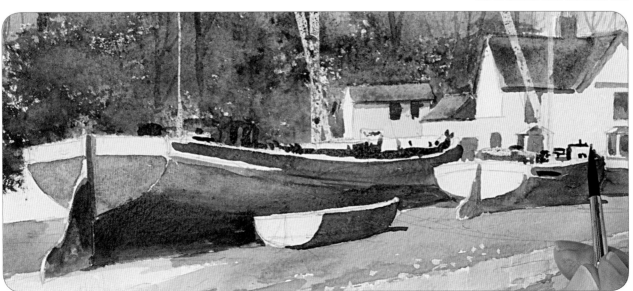

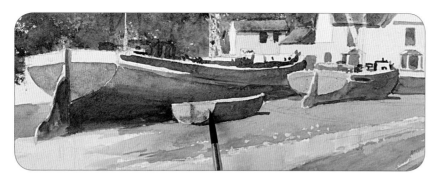

21 Add raw sienna to the burnt umber and ultramarine mix and paint the sterns of the boats. Shade the smallest boat with burnt umber and ultramarine.

22 Paint the top of the stern of the largest boat with cobalt blue.

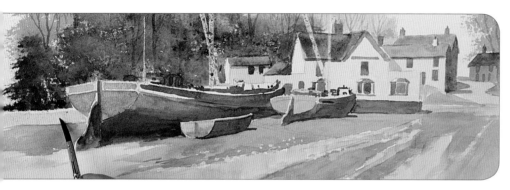

23 Use the stern mix of raw sienna, burnt umber and ultramarine to paint the roads on the far right and far left of the painting.

24 Paint the furled sail with burnt sienna, then drop in shadow for the shaded parts, wet into wet.

25 Use the 13mm (½in) flat brush with a mix of ultramarine and burnt umber to paint reflections of the largest boat with little horizontal ripples. Allow to dry.

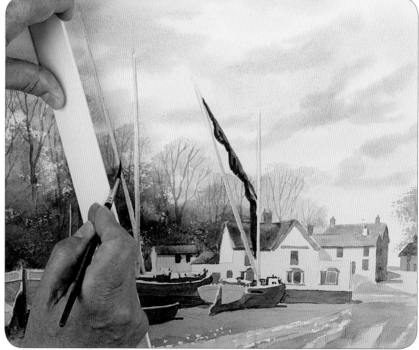

26 Remove the masking fluid with a clean finger. Paint the masts using a ruler with the small detail brush and a pale mix of raw sienna. Allow to dry. Shade the right-hand sides with ultramarine and burnt umber.

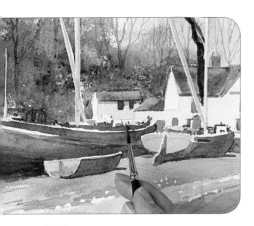

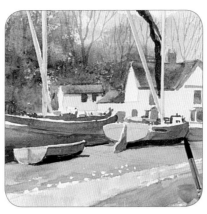

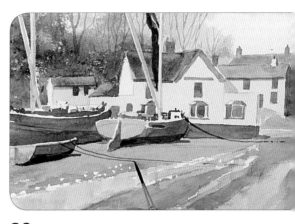

27 Add colour to the boat clutter with cadmium red and cadmium yellow.

28 Darken the undersides of the two forground boats with the medium detail brush and burnt umber and ultramarine.

29 Use the half-rigger to paint the mooring ropes coming from the boats with the same mix.

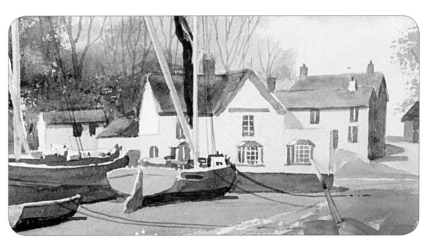

30 Use the ruler and the same brush and mix to paint the rigging of the boats.

31 Paint the window frames with the half-rigger and white gouache.

32 Paint the fascia of the main building with burnt umber and ultramarine as a finishing touch.

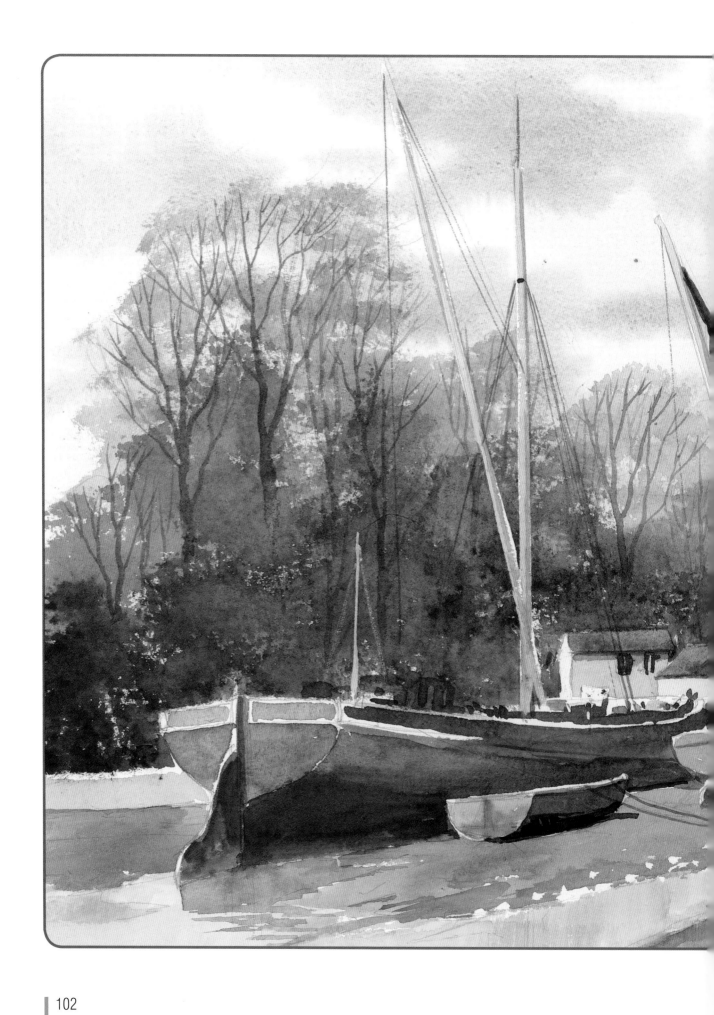

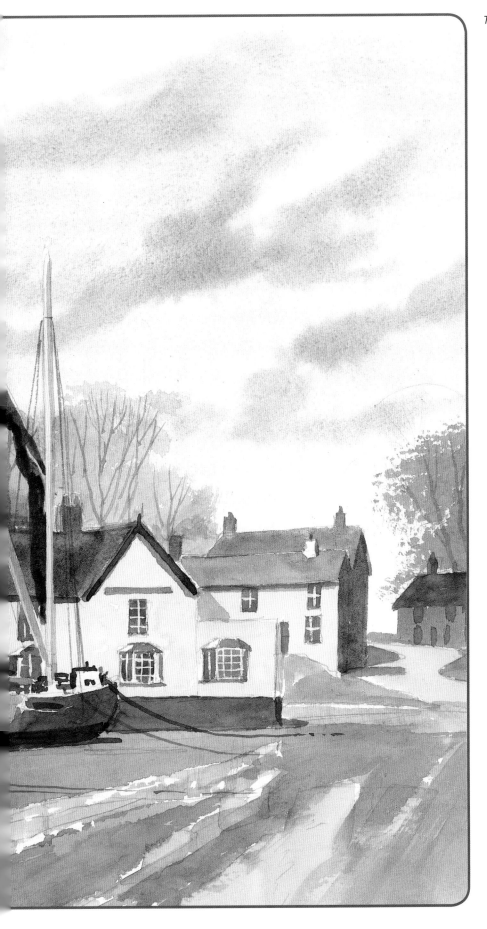

The finished painting.

103

Evening Boats

This project has a simple composition and focal point, and everything directs you towards the centre of the painting; even the light on the water draws you like a moth to a lamp. The sparkling light on the water is created by lots of masking fluid dots and the distant hills recede into the painting, as each layer becomes lighter as they get further away. In the same way, the water in the foreground is quite dark and gradually becomes lighter as it recedes to the far shore.

You will need

Colours: raw sienna, cobalt blue, burnt umber, ultramarine blue, shadow, midnight green, burnt sienna

Brushes: golden leaf, large detail, 13mm (½in) flat, small detail, half-rigger

Masking fluid and old brush

Ruler

1 Draw the scene and mask the sparkles on the lake and the lit parts of the rowing boat with masking fluid.

2 Wet the sky with the golden leaf brush and clean water, then brush in raw sienna over the lower sky and mountain tops. While this is wet, paint horizontal strokes of cobalt blue down from the top.

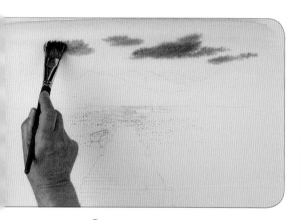

3 While the sky is wet, dab on clouds with a dark mix of burnt umber, ultramarine blue and a touch of shadow. Allow to dry.

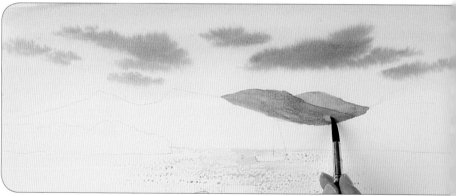

4 Use the large detail brush and a mix of cobalt blue with a touch of shadow to paint the distant hills.

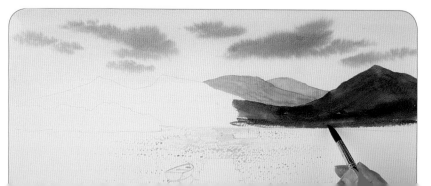

5 Paint the hills coming further forwards with a darker mix of the same colours.

6 Mix shadow, burnt umber, ultramarine and midnight green and paint the headland on the left, suggesting the shape of the treetops.

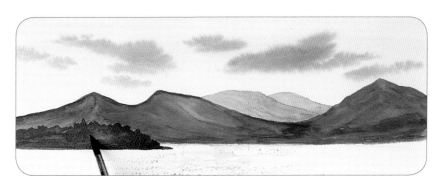

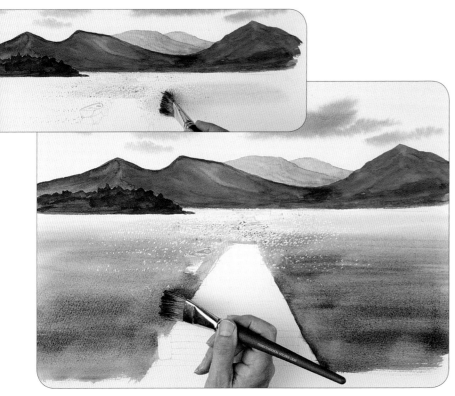

7 Wet the lake area with the golden leaf brush and clean water, then paint a wash of raw sienna along the horizon and coming forwards, in horizonal strokes. Mix shadow and burnt sienna and paint this below the horizon, over the sparkles. Strengthen the mix as you move towards the foreground. Allow to dry.

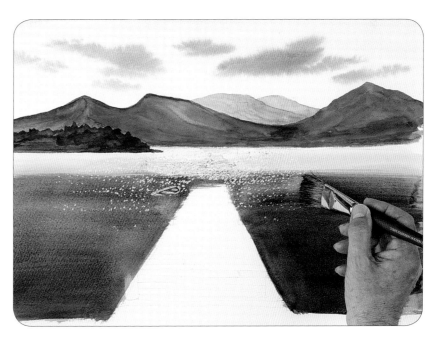

8 Make a stronger mix of ultramarine, burnt sienna and shadow, and apply a wash of this over the darker part of the water, wet on dry.

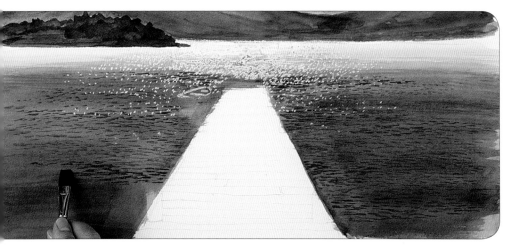

9 Make a stronger mix of the same colours and use the 13mm (½in) flat brush to paint little horizontal strokes for ripples.

10 Use the small detail brush with a mix of ultramarine, burnt umber and shadow to paint the dark parts of the little rowing boat.

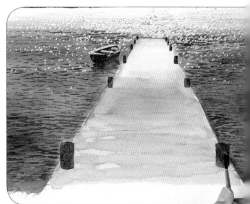

11 Wet the jetty with clean water, then use the large detail brush to paint a pale wash of raw sienna at the back. Paint a darker mix of burnt umber and shadow further forwards and blend this into the wet raw sienna for a graduated effect. Allow to dry.

12 Paint the posts on the jetty with the small detail brush and a mix of ultramarine and burnt umber.

13 Use the half-rigger with the same mix, and a ruler to help you paint the planking across the jetty. Allow to dry.

14 Remove the masking fluid with clean fingers. Use the small detail brush with a dark mix of ultramarine and burnt umber to tidy the previously masked shape of the rowing boat, and add a mooring rope.

15 Paint the yacht and its reflection with the same dark mix and the half-rigger. Use a ruler to help you paint the mast and rigging.

16 Dot in a hint of a rippled reflection of the mast in the water.

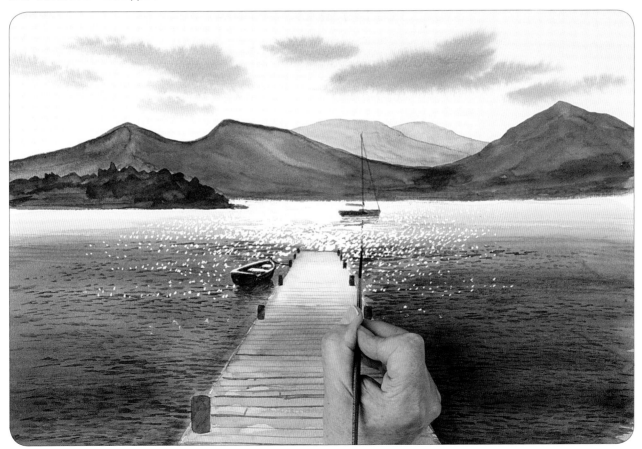

The finished painting.

Ship at Sunset

Red sails in a sunset – how romantic! The sky is a soft, uncomplicated sunset, which is not too dominant, as you don't want it to compete with the tall ship in full sail. A light wind is all it takes to ruffle the water and reduce the reflections of the ship to many short horizontal brush strokes. The headland in the distance helps balance this simple composition.

You will need

Colours: raw sienna, alizarin crimson, cadmium yellow, cobalt blue, burnt umber, shadow, ultramarine blue, burnt sienna

Brushes: golden leaf, medium detail, small detail, large detail, half-rigger, 19mm (¾in) flat, 13mm (½in) flat

Ruler

1 Draw the ship. Use the golden leaf brush to wet the sky area with clean water, going over the ship. Paint a pale mix of raw sienna and alizarin crimson over the bottom of the sky. Blend this into a second wash of cadmium yellow and alizarin crimson higher up.

2 While the sky is still wet, paint cobalt blue at the top of the painting and fade it down into the yellows.

3 Mix alizarin crimson and cobalt blue and paint clouds, still working wet into wet.

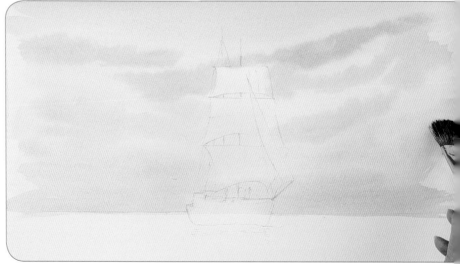

4 At the bottom of the sky, paint a pink mix of alizarin crimson with a little raw sienna. Allow the sky to dry.

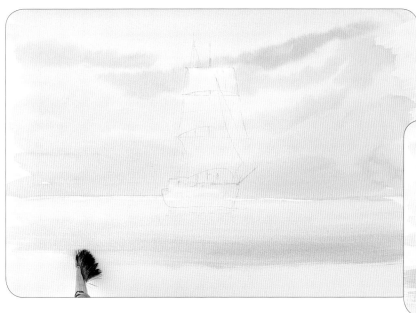

5 Paint raw sienna below the horizon for the reflection, then, below this, blend in a wash of cobalt blue and alizarin crimson. Strengthen this in the foreground with a wash of burnt umber and shadow. Allow to dry.

6 Use the medium detail brush and a mix of cobalt blue and burnt umber to paint the hull of the ship, then darken the right-hand side with ultramarine blue and burnt umber.

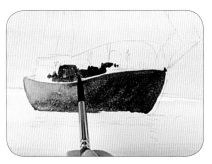

7 Suggest clutter on the deck of the ship with the same mix, then drop in some burnt sienna to vary it. Leave a white line round the gunwhale.

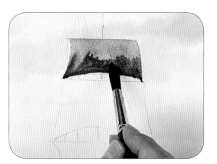

8 Paint the top sail with raw sienna and burnt sienna, then while this is wet, drop in shadow for the shaded parts.

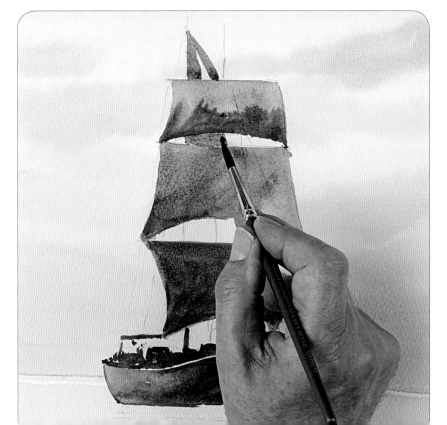

9 Paint all the sails in the same way, with burnt sienna and raw sienna first, then shadow dropped in wet into wet. Paint the furled sail behind the others with burnt sienna and raw sienna.

111

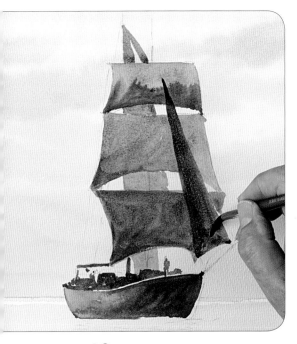

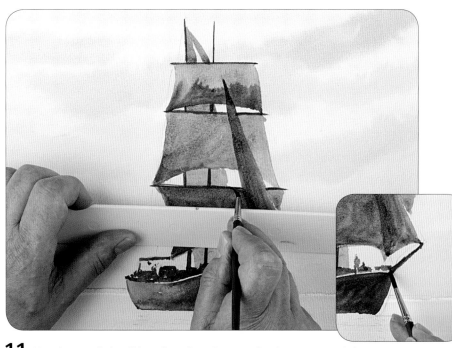

10 Paint the spinnaker (the sail at the front) with a mix of cobalt blue and burnt sienna.

11 Use the small detail brush and a ruler to paint the masts and the cross bars of the sails with the same mix. Paint the prow.

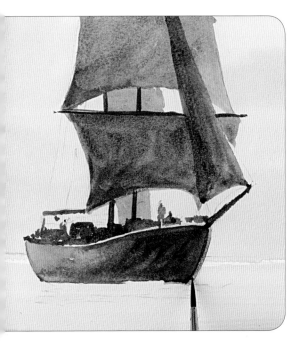

12 Paint the lower part of the prow where it catches the light with raw sienna.

13 Use the half-rigger with a grey mix of burnt umber and ultramarine to paint the rigging, using a ruler to help you where necessary.

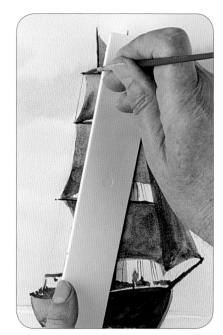

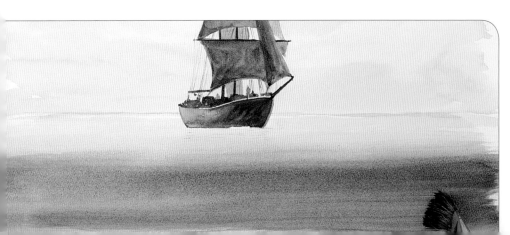

14 Mix raw sienna, alizarin crimson, and shadow and use the golden leaf brush to deepen the colour of the sea in the foreground.

15 Wet a 19mm (¾in) flat brush and squeeze it out so that it is just damp. Lift out colour in horizontal strokes over the foreground sea, to create a rippled effect.

16 Use the 13mm (½in) flat brush to paint tiny ripples nearer to the horizon with strong burnt sienna.

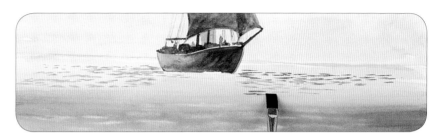

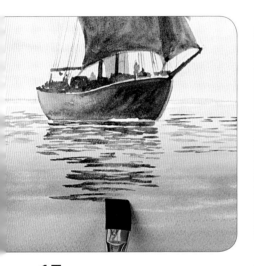

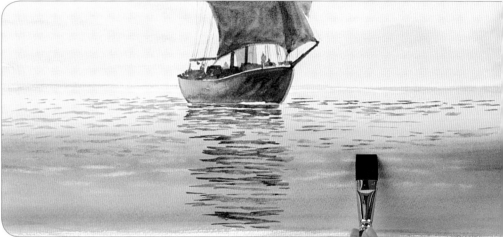

17 Paint the rippled reflection of the hull with the 19mm (¾in) flat brush and a mix of ultramarine and burnt umber, then the reflection of the sails lower down with burnt sienna and shadow.

18 Add touches of ripples on either side of the ship in the same way.

19 Use the large detail brush and a mix of burnt sienna and shadow to paint a distant headland and suggest rocky texture with a darker mix.

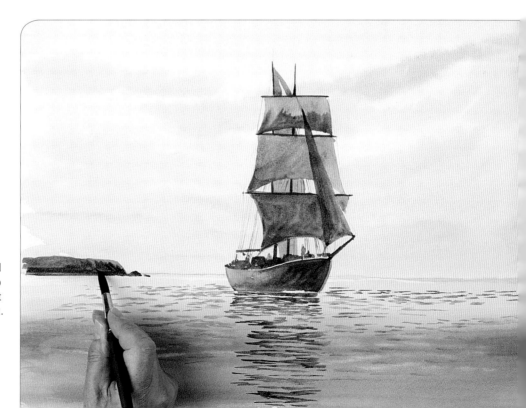

The finished painting.

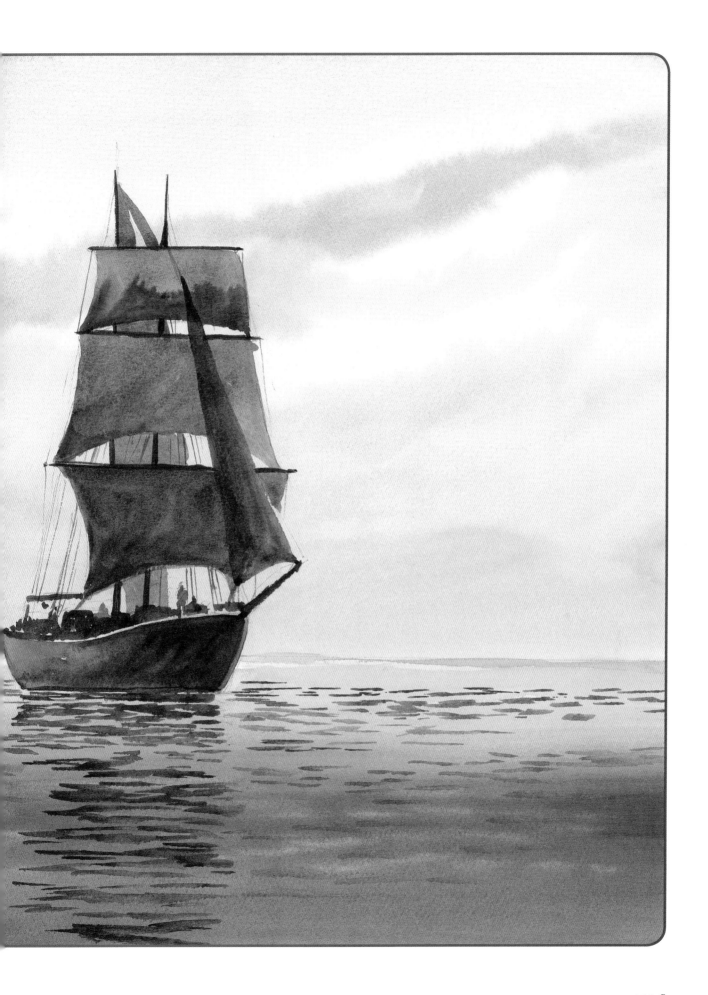

Harbour Village

There are many elements to this project: a soft, gentle sky, misty distant trees, buildings, windows and roofs. The scraping-out technique used in the harbour wall takes some practice, but it gives a very realistic finish. No harbour is complete without some boats, and the boats on the shoreline here make a charming focal point.

You will need

Colours: raw sienna, ultramarine blue, burnt umber, cobalt blue, sunlit green, midnight green, cadmium yellow, burnt sienna, shadow, cadmium red, country olive, white gouache

Brushes: golden leaf, large detail, medium detail, small detail, foliage px, 19mm (¾in) flat, half-rigger, golden leaf

Masking fluid and old brush

Paper mask

Plastic card

1 Draw the scene, then use masking fluid to mask the lighter parts of the boats, the clutter on the wheelhouse of the larger boat, the mooring lines, the waterline and ripples.

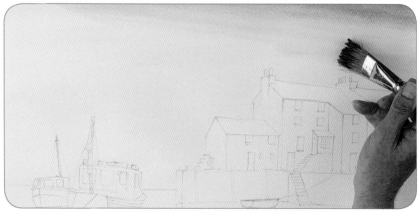

2 Wet the sky area with the golden leaf brush, cutting round the buildings. Paint a pale wash of raw sienna over the lower sky. Next pick up ultramarine blue and paint this in diagonal bands from the top right, fading it into the raw sienna.

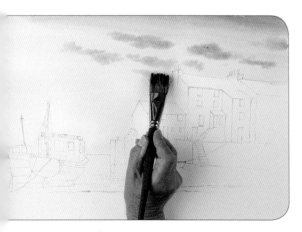

3 Mix ultramarine and burnt umber and brush in clouds wet into wet.

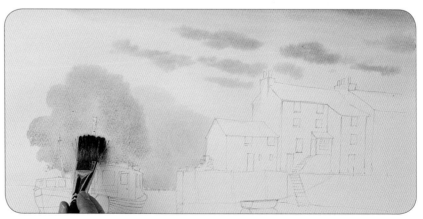

4 Paint the hazy distance with a pale mix of cobalt blue with a touch of sunlit green, still working wet into wet, before the sky dries. Make a stronger mix of the same colours and paint this to the left to suggest a distant headland.

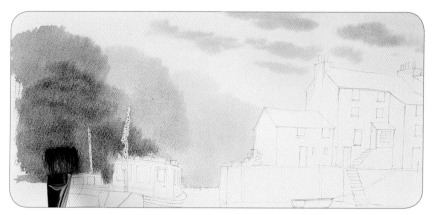 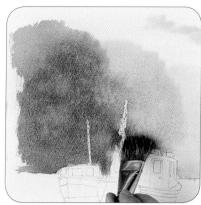

5 Make a stronger mix of cobalt blue and midnight green and paint this on the far left to create the nearest part of the headland. While this is wet, drop in a still darker mix of ultramarine and midnight green as a dark background for the boats.

6 Still working wet into wet, stipple on a light mix of sunlit green and cadmium yellow. The lighter colour will push away the darker background, creating texture as well as highlights.

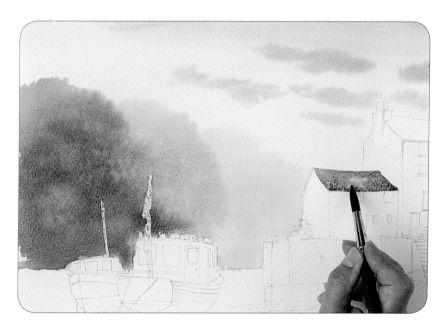

7 Use the large detail brush to paint the roof on the left of the group with ultramarine and burnt umber, then while it is wet, drop in raw sienna to add a weathered texture.

8 Paint the second roof with a mix of cobalt blue and burnt sienna. While this is wet, drop in burnt sienna, and then raw sienna.

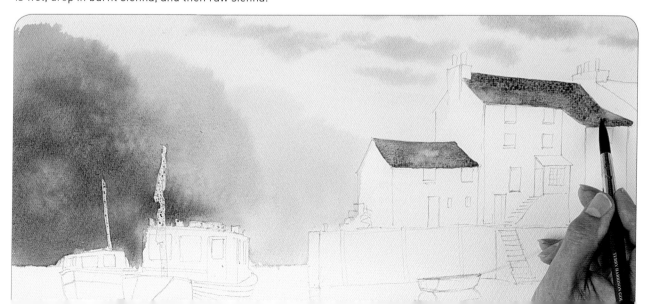

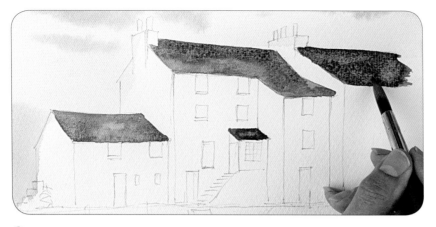
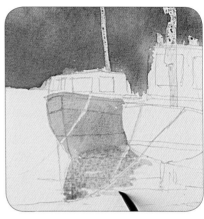

9 Paint the porch and the final roof with ultramarine and burnt umber, and drop in raw sienna, which will granulate and create texture.

10 Wash over the hull of the left-hand boat and its reflection with the medium detail brush and cobalt blue.

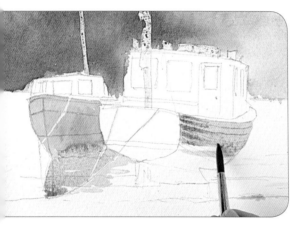
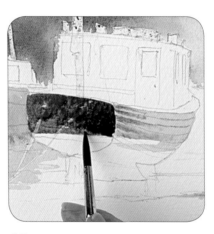
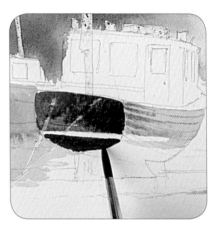

11 Paint the hull of the right-hand boat with raw sienna, then push burnt sienna into it from the left, wet into wet. It will spread out and create form.

12 Allow to dry. Paint the stern with burnt sienna, then drop in shadow while the first wash is wet.

13 Mix burnt umber, cadmium red and shadow and paint the underside of the hull.

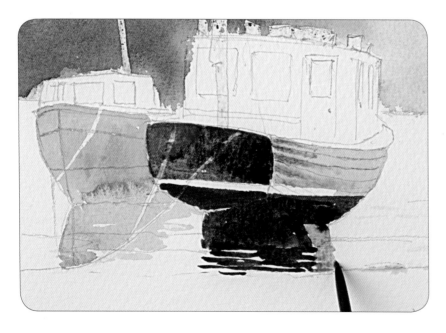

14 Add more shadow to paint the underside of the hull, then add ultramarine to paint the reflection, which should break into horizontal ripples. Paint the keel on the right with pale burnt sienna.

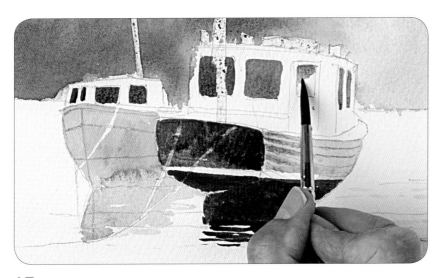

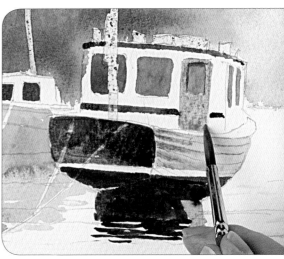

15 Mix burnt umber and ultramarine and paint the windows of the wheelhouses of both boats.

16 Paint stripes of detail on the right-hand boat with burnt umber, then paint the door with raw sienna.

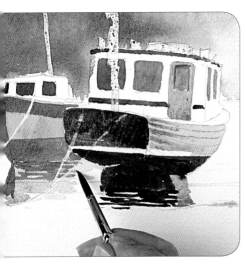

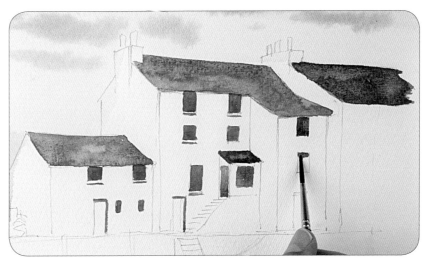

17 Paint over the pale blue of the second boat with stronger cobalt blue and continue this into the reflection, creating ripples with horizontal strokes.

18 Use the small detail brush to paint the darks of the windows with a mix of ultramarine and burnt umber. Paint a line under each windowsill.

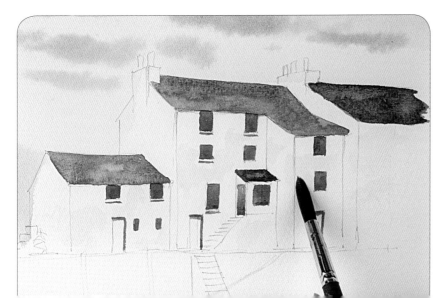

19 Change to the large detail brush and dab a very pale mix of raw sienna on to the white of the buildings.

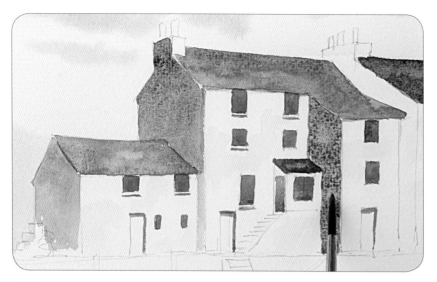 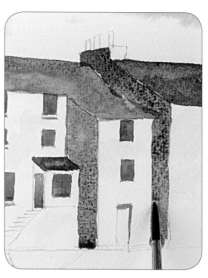

20 Use the medium detail brush and a mix of shadow and cobalt blue to paint the shaded gable ends of the buildings. While this is wet, drop in burnt sienna to create texture. Paint the shaded part of the middle building in the same way, then drop in raw sienna.

21 Paint the gable end of the right-hand building with a strong mix of cobalt blue and shadow, then drop in burnt sienna wet into wet.

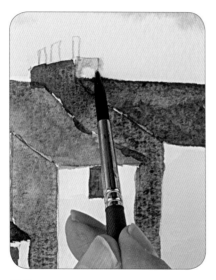 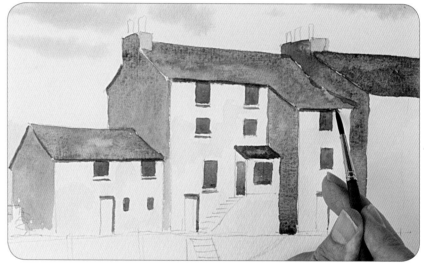

22 Paint the lit part of the right-hand building's chimney with a very pale mix of ultramarine and burnt umber.

23 Use the small detail brush to create the effect of guttering with a dark mix of ultramarine and burnt umber. Allow to dry.

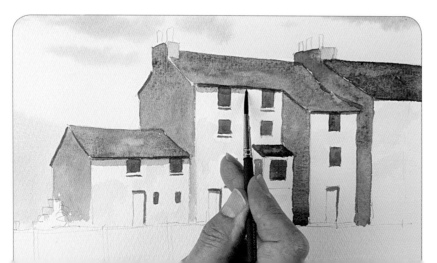

24 Paint shade beneath the guttering with cobalt blue and a touch of shadow.

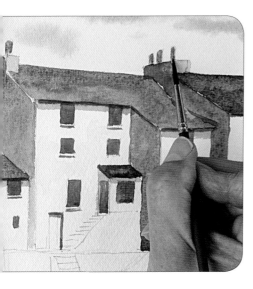

25 Paint the chimney pots with burnt sienna.

26 Mask the buildings above the harbour wall with a paper mask, and stipple raw sienna on to the wall itself using the foliage brush.

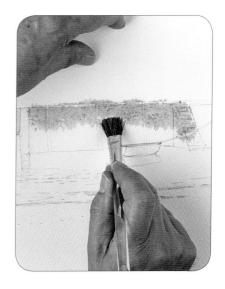

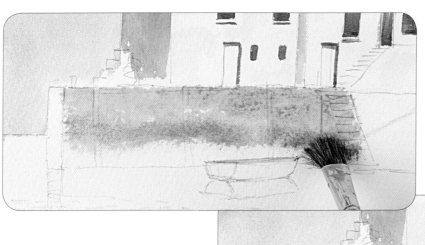

27 While the wall is wet, stipple sunlit green at the bottom, then country olive on top of this, using the paper mask at the bottom of the wall.

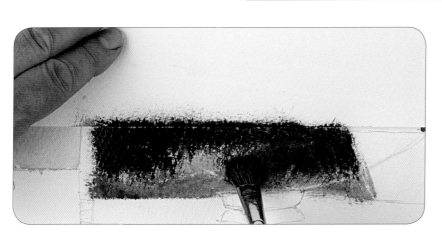

28 Place the paper mask at the top of the wall and stipple on a thick mix of ultramarine and burnt umber.

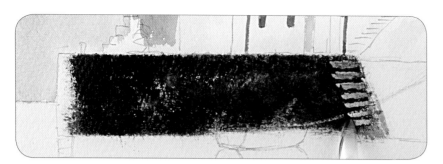

29 Use a brush handle to scrape out the highlights of the steps. Here I am using the specially designed acrylic resin handle of the foliage px brush.

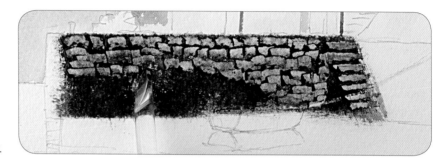

30 Scrape out the stones in the wall in the same way.

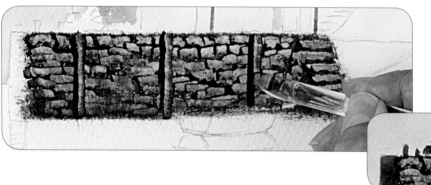

31 Paint in the three fenders with the small detail brush and ultramarine and burnt umber, then scrape out the lit sides with a brush handle. Use the small detail brush and the same mix again to paint lobster pots and other clutter on top of the wall.

32 Mix ultramarine, burnt umber and country olive and use the large detail brush to paint the second part of the harbour wall that turns a corner after the steps. It should be very dark as it faces away from the light.

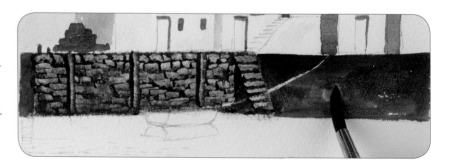

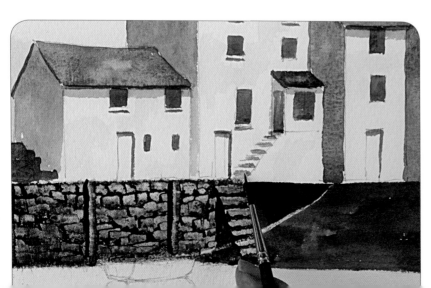

33 Change to the small detail brush and use a pale mix of ultramarine and burnt umber to paint the steps leading up to the house.

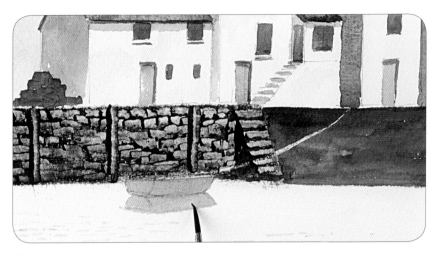

34 Paint the doors of the houses with pale mixes, one of cadmium red, one of cobalt blue and one of country olive. Paint the rowing boat and its reflection with the cadmium red.

35 Mix white gouache to the consistency of full cream milk and use the half-rigger to paint the window frames.

36 Mix shadow and cadmium red and paint the shaded stern and underside of the boat, and their reflections.

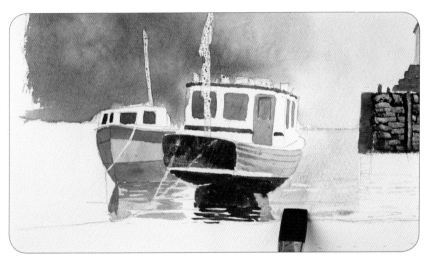

37 Wet the water area to the left of the harbour wall with the 19mm (¾in) flat brush and clean water, then apply a pale wash of cobalt blue. While this is wet, add a touch of country olive to imply reflections of the background trees.

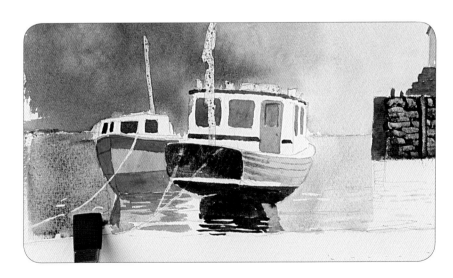

38 Mix midnight green and ultramarine and drag the colour down on the left of the boats.

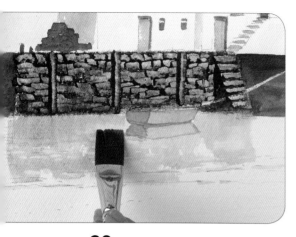

39 Paint the reflection of the harbour wall with downward brushstrokes of raw sienna, then a little sunlit green.

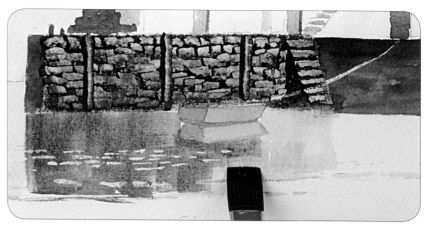

40 Pull down a mix of ultramarine and burnt umber in the same way, still painting wet into wet. Stop at the water's edge.

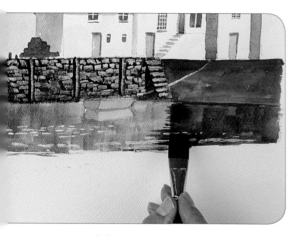

41 Mix ultramarine, burnt umber and country olive to paint the reflection of the dark right-hand section of the wall. Suggest ripples where the dark colour meets the lighter reflection.

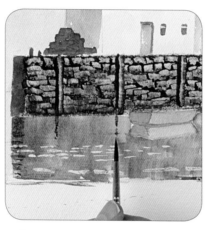

42 Use the small detail brush and a mix of ultramarine and burnt umber to paint reflections of the fenders. Break up the ends of the reflections into ripples.

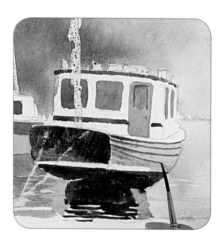

43 Mix burnt sienna and shadow and use the half-rigger to paint the clinker lines of the main boat.

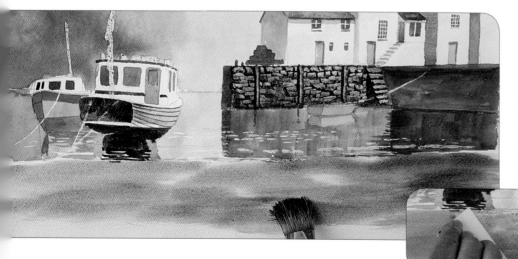

44 Brush raw sienna over the shore with raw sienna using the golden leaf brush, then paint burnt umber and country olive over the top, working wet into wet. Use a plastic card to scrape away texture.

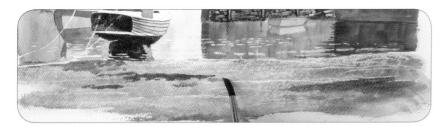

45 Paint seaweed on the shore with the large detail brush and a mix of country olive and burnt umber. Allow the painting to dry.

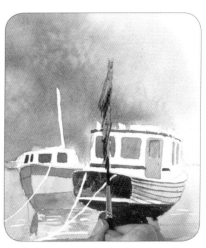

46 Remove the masking fluid with a clean finger. Use the small detail brush to paint the sail of the main boat with burnt sienna, then add shade with shadow.

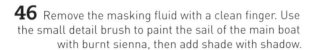

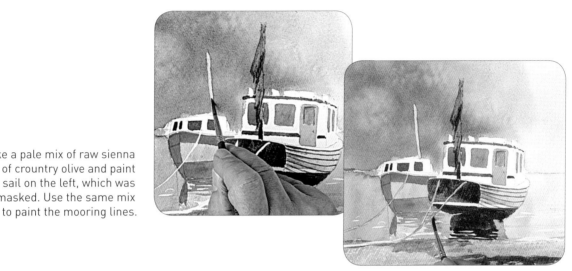

47 Make a pale mix of raw sienna and a touch of crountry olive and paint the furled sail on the left, which was previously masked. Use the same mix to paint the mooring lines.

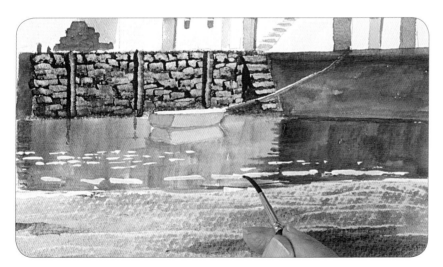

48 Paint over the previously masked ripples with a pale mix of cobalt blue.

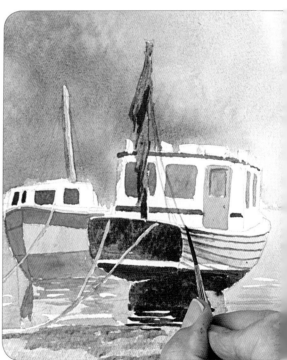

49 Shade the left-hand boat's furled sail and paint the rigging of both boats with the half-rigger and a light grey mix of ultramarine and burnt umber.

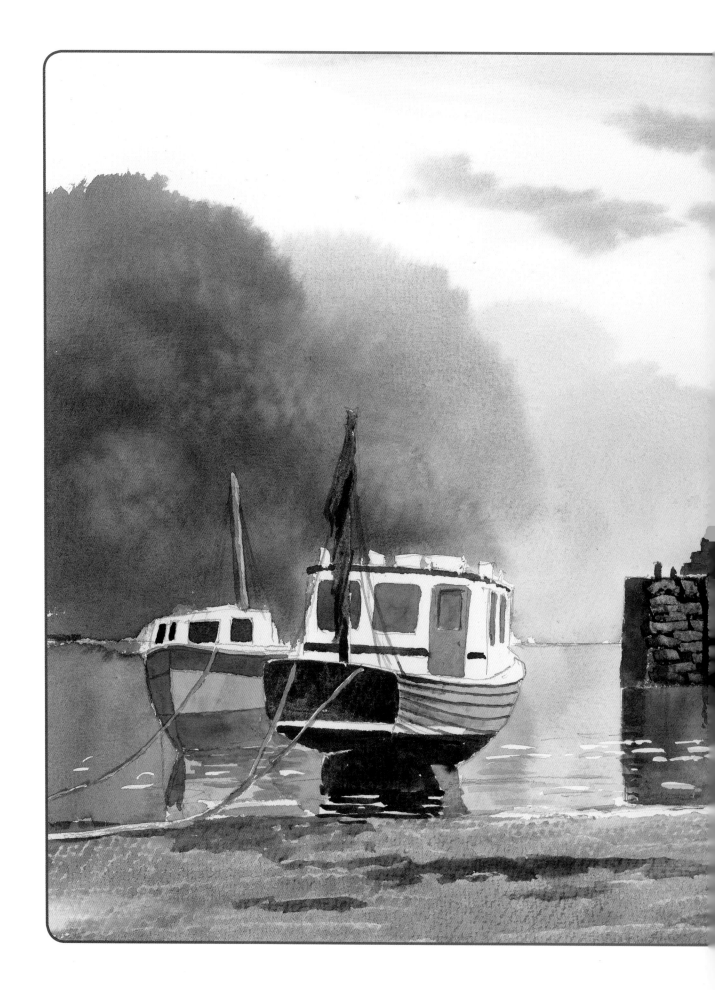

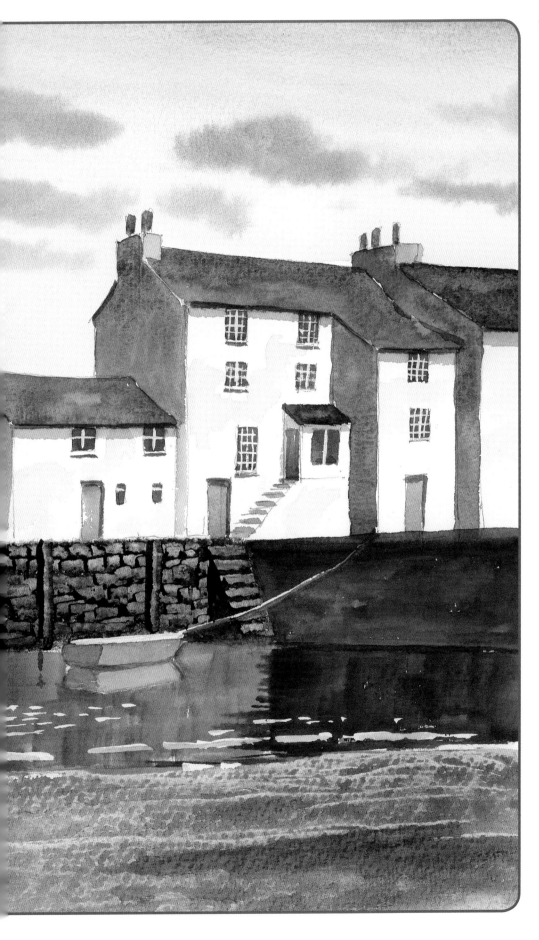

Index

Harbour at Low Tide

This painting is similar to the project Harbour Village on page 116 but with added buildings and figures on the quayside.

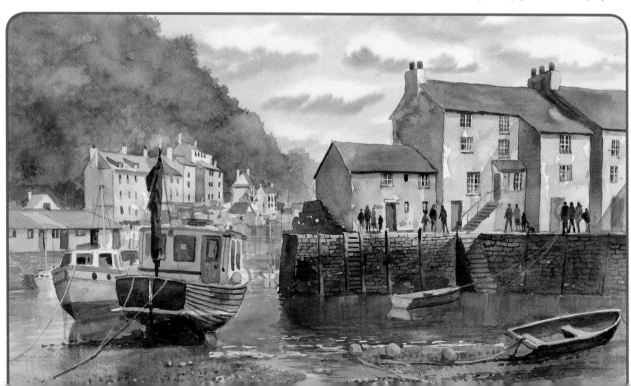